M000035310

IMAGES
*of America*

# ITALIAN
# MILWAUKEE

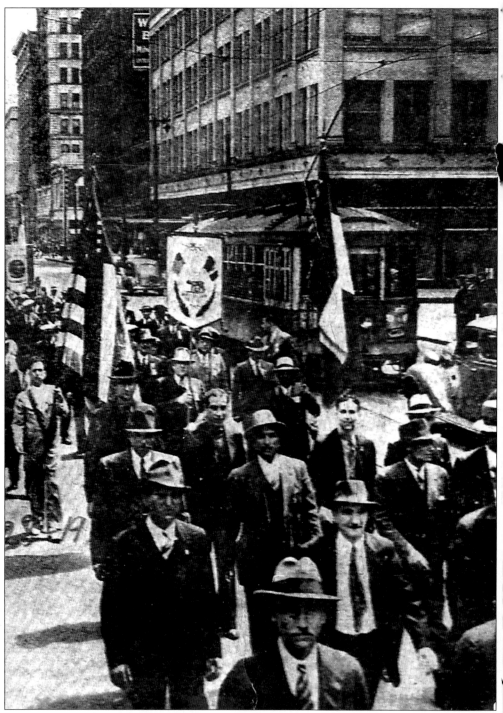

At the height of the Great Depression in 1933, a parade of Italian labor and religious societies trooped through downtown Milwaukee to highlight the need for jobs. Several thousand marchers are seen here on Wisconsin Avenue looking north toward 4th Street. (Photo courtesy of Mario A. Carini, Italian Community Center.)

# IMAGES
# *of America*

# ITALIAN
# MILWAUKEE

Martin Hintz

Introduction by Mario A. Carini
President, Italian Community Center

ARCADIA

Published by Arcadia Publishing,
Charleston SC, Chicago IL, Portsmouth NH, San Francisco CA

Printed in Great Britain

Library of Congress Catalog Card Number: Applied for

For all general information contact Arcadia Publishing at:
Telephone 843-853-2070
Fax 843-853-0044
E-mail sales@arcadiapublishing.com
For customer service and orders:
Toll-Free 1-888-313-2665

Visit us on the internet at http://www.arcadiapublishing.com

# CONTENTS

# ACKNOWLEDGMENTS

The author wishes to thank the many Milwaukeeans and others who helped in researching this book and finding these marvelous photos. Particular appreciation is extended to those families and individuals who loaned priceless portraits, memories, and mementoes of their Italian heritage.

Included in a long, long list are:

Geraldine Accetta; Giorgio Argondizzo; Terry Aveni; Lawrence Baldassaro; Frank Balistrieri; Mario A. Carini; Nick Contorno; the Dentices; Tom Dentice; Mike D'Amato; Michael A. (Michael D) D'Acquisto; Rosemary De Rubertis; Dan and Mike Diliberti, John and Jean DiMotto, Ralph Franciosi; the Fazzaris, Sgt. Ken Henning; Joe and Mary Glorioso; Jerry Grillo; Joseph Iannelli; William A. Jennaro; Patti Keating Kahn; Peter LaBarbera; Vincent James Lo Duca; Pat Marcella; Rose Mastrogiovanni; Joe and Girolama (Mimma) Megna; Tony Migliaccio; Mike Mille, Jr.; Mary Louise Mussoline; Tom Nardelli; Fran Naczek-Maglio-O'Brien; Faith O'Connell; Kat O'Connell; Betty Puccio; Ignacio Reina; the Rosetto family; Robert Ruggieri; Anna Tarantino SanFelippo; Joe Sanfelippo; Jean Stemper; Maria Vella Sali and her brothers, Giuseppe and Luigi; Susanne and Rose Vella; Brian Witt and Mary Crivello Witt; and many, many more wonderful Milwaukeeans who love their community and their heritage.

Plus, this book couldn't have been accomplished without the assistance of the Italian Community Center; T.H. Stemper Company; Three Holy Women Parish; the Florentine Opera; St. Joan Antida High School; the Milwaukee Brewers; Wisconsin Department of Transportation; Marquette University archives; Wisconsin Supreme Court; Italian Consulate-Chicago; Wisconsin State Fair Park; Milwaukee Police Department; *The Italian Times*; Library of Congress Prints and Photographs Division; High Point University; Waukesha Symphony Orchestra; and the 440th Airlift Wing, Wisconsin Air National Guard.

# INTRODUCTION

Escaping from the Old World's grinding poverty, Milwaukee's first Italian community was drawn to a better life on the shores of Lake Michigan. At least in America, they believed that they could finally get away from *la miseria*. High taxes, peasant-landlord confrontations, hunger, illiteracy, and a shortage of decent-paying jobs were among the many reasons contributing to the exodus of the late 1800s and early 1900s. Puglia, Calabria, Campania, Abruzzi and Sicily were among the regions contributing the most to the flood.

Even Italians from the north eagerly looked for golden opportunities elsewhere, rather than continuing to struggle under the strictures of the Kingdom of Italy. Many of them went to South America, while most of the southern Italians came to the United States.

Of course, the newly-arrived Italians in Milwaukee confronted more economic hardship and outright discrimination when they arrived. Often, they were viewed as competitors by others who had arrived earlier to find their way in the New World. Yet the promise of jobs continued to lure the émigrés, especially from the impoverished south of Italy.

At first, their numbers were low. According to the U.S. census of 1880, 87 Italians were in Milwaukee. By 1890, there were 137. In 1900, the number had grown to 726, compared to the 16,000 in Chicago. In 1910, there almost 3,000, compared to 45,000 in Chicago. The numbers kept growing until around World War I, when Italian immigration to Milwaukee began to level off. An Italian consul, Arminio Conte, was assigned to Milwaukee in 1907.

Milwaukee's burgeoning industrial infrastructure needed workers. The Italians were glad to be among the torrent of other nationalities eager to accommodate the voracious employment appetites of foundries, the garment industry, and the railroads. Yet not all arrivals were unskilled workers. Dozens of craftsmen who were experts in masonry and carpentry also came to Milwaukee to work on the city's most prominent public structures and private mansions.

Sometimes, the Italians had planned to travel further west, particularly out to California, but were stalled by a lack of money once they reached Wisconsin. So they stayed. As they settled in, many sent cash home to bring more relatives to Milwaukee. Or young men traveled back to their home villages to find a wife and then returned to the city.

While many in this first wave continued to speak Italian or a dialect from their home communities, others sought to acclimatize themselves by learning English. As a result, many young second and third generation Italians needed instruction in Italian in order to communicate with the older generations.

It remains a challenge to track the interlocking families that make up Milwaukee's Italian

community. For instance, the Balistreri name, no matter how it is spelled, is older than the Roman Empire and is actually Spanish, originating in the Balearic Islands. The word *balestra* was given to the island's expert archers who served in the Roman army. When Sicily was ruled by Spain's House of Aragon from 1240 to 1400, many Balistreris were sent there, settling primarily around Messina, and eventually emigrating to the Palermo area. When the family finally made its way to the States in the early 1900s, the spellings were often inadvertently changed at Ellis Island. The names in this book reflect these changes. Milwaukee has a plentiful supply of other family names: Bartolotta and Bartoletti; DiGiacomo and Di Giacomo; DiMotto, Demotto and Di Motto; DiMiceli and Di Miceli . . . and there are many more twists and turns throughout the phone book!

And what's in a name? Actually, a lot! A number of Milwaukeeans have made it into the *Who's Who Among Italian Americans*, published by the National Italian American Foundation of Washington, D.C. For instance, among the 1,300 honorees in the 1993 edition, seven members of the Italian Community Center were mentioned. They included historian Mario A. Carini, a retired Milwaukee Public School (MPS) teacher and eventual president of the ICC; Sam Ceraso, another retired MPS teacher and active UNICO member, both nationally and locally; Nick Contorno, Marquette University's band director and Festa Italiana's first music director; Father Albert DiUlio, president of Marquette University; Dr. Edward Leone, a past ICC president; public relations executive and journalist Robert Ruggieri; and Grace Shoplas, a long-time MPS teacher and an Italian Person of the Year (1991).

And there are the thousands of additional, but less prominent, faces among Milwaukee's vast Italian community. Remember when Frank Scalzo still made wine the old way, by stomping the grapes? And Mrs. Frances Balistreri's pastries were always featured at the Italian Christmas celebrations at the Milwaukee Public Museum. Jean Lo Menzo had a tailor shop at 1027 E. Brady Street for nearly 40 years.

The Italians are here to stay.

    —Mario A. Carini, President, Italian Community Center

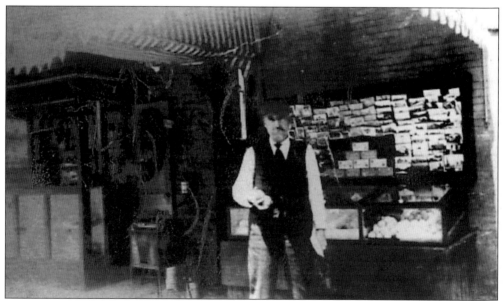

Joseph Puccinelli stood outside his fruit stand at the corner of East Michigan and North Water streets in the summer of 1916. He was one of many Sicilian émigrés who set up shop in the old Third Ward, gravitating toward the produce business. (Photo courtesy of Faith O'Connell.)

# One
# COMING TO AMERICA

The peak of early immigration to Milwaukee by Italians was from the late 1880s to the World War I era. Another big wave came after World War II, followed by a third influx in the 1970s and 1980s. The latter arrivals were primarily business people, many of them corporate managers who often retained their Italian citizenship and eventually flew back home when their assignments were concluded. But, as always, there were plenty of other young Italian men and women eager to reaffirm their new life in a brave new world. They came, liked what they saw in Milwaukee, and stayed.

The beacon of liberty and freedom beckoned natives of Sant' Elia, Bari, Bagheria and Santo Stefano di Camastra. A wall of the Maria S.S. del Lume Church in Porticello, Sicily, has a list of the names of people from the town who came to Milwaukee, San Francisco, Chicago, and other American cities. In Italy, they may have been fishermen or peasant laborers. But a steamer ticket to the United States meant passage to streets paved with gold and untold numbers of chickens in every pot. While those dreams might not have been fulfilled, the lure of what promised to be a better life remained a powerful draw.

It was often hard to break homeland ties, however, especially in the early 1900s, when the rumblings of war rattled Europe. A number of Milwaukee men were recruited by Italy to fight alongside their countrymen, lured by the offer of free passage back to Europe, according to Ted Mazza, an early historian of the Italian community. Yet in a newspaper article from 1979, Mazza went on to rap what he called "the greatest discrimination ever enacted in the Senate"—the restrictive immigration quotas backed by Senator John Cabot Lodge and signed by President Calvin Coolidge. "Another nitwit," Mazza asserted.

The United States didn't always warmly welcome the emigrants. In the spring of 2004, th e Milwaukee County Historical Society presented a 1940s photo exhibit entitled Una Storia Segreta: When Italian Americans Were Enemy Aliens. The display showcased material that brought attention to the evacuation and internment of Italian Americans, the process which eventually led to the Wartime Violation of Italian American Civil Liberties Act.

But the Italians kept coming, despite restrictions and anti-émigré feeling. Think what it must have been like for Joe and John Guiffre, as they stood at the railing of the passenger ship that brought them to America in 1940. The two brothers eventually made their way to Milwaukee where they became active in the fruit business. The Guiffre (originally Giuffre) brothers were only two among thousands of Italians and Sicilians who were making their way to the city. Once ensconced and working, they often paid the passage for other relatives.

Once in their new home, it was picture time. Photographs were important to send to the Old County, to show what a fine life was to be had in America (even if the underlying message was that it was always a challenge). Flowers were often a focal point in early 20th century portrait studios, used to soften these portraits. Once all the stage settings were adjusted, it was lights…camera…photo! Excited subjects such as Gina Tornabene then proudly stood with her family, ready to face the world.

Most Italian Americans went on to become secure, successful members of the Milwaukee community despite any obstacles in their path. Today, they remain among the most vibrant, colorful members of the city's diverse ethnic palette.

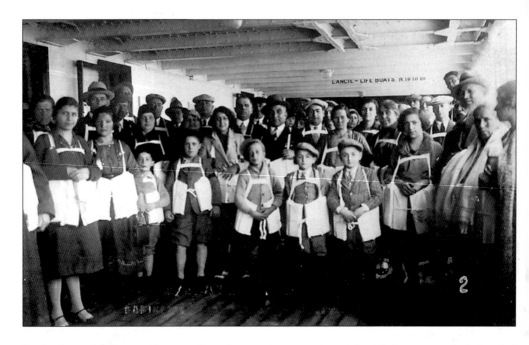

Young Pietro Vella was 10 years old, sailing to America aboard the *SS Augustus,* which headed out to sea on April 10, 1931, arriving April 21, after picking up passengers in Genoa and Naples. He's the third boy from the right in the front row, wearing his life preserver for a shipboard drill. On this trip, young Vella traveled with his mother, Antonina. He was also in front of the congregation praying aboard the ship during a deckside mass probably said by the ship's chaplain, Father Alessandro Cominello. Pietro is the young man on the left facing toward the bottom of the photo. The ship was captained by Francesco Tarabotto. (Photos courtesy of the Vella family.)

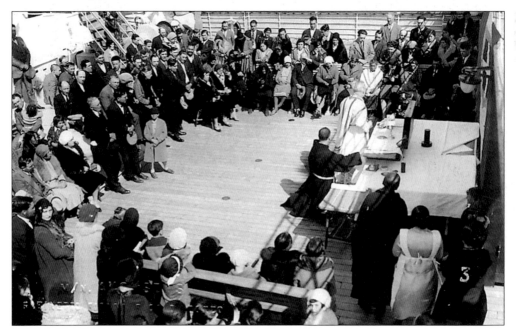

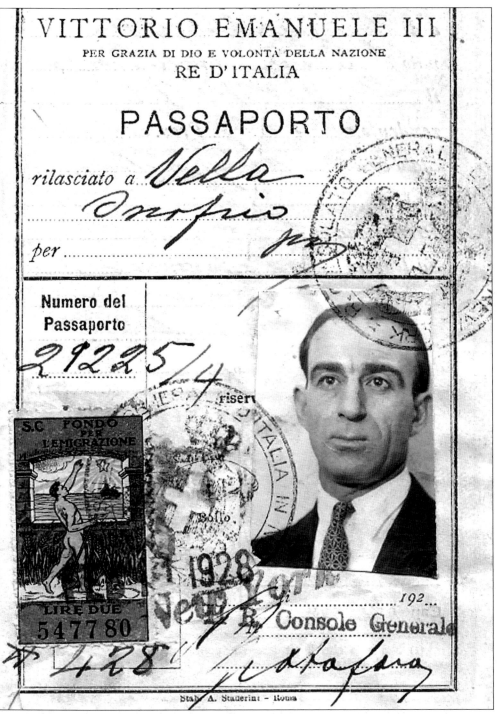

A passport was one of the most important documents a traveler could carry. Onofrio Vella was a regular transatlantic traveler since first coming stateside in the 1920s, frequently traveling back and forth from Italy and on to Milwaukee where he was a factory worker. Vella died in 1966. (Photo courtesy of the Vella family.)

Giuseppe Dentici was born February 25, 1863 in Sant' Elia, Sicily, and died October 12, 1941. Dentice came from a long line of fishermen and decided there would be a better life in America, emigrating in early 1900s. He and his family lived on Chicago Street in the old Third Ward. Giuseppe married Caterina D'Acquisto in 1903 at our Blessed Virgin of Pompeii Church and the couple eventually had four boys and four girls. He was a street sweeper on Wisconsin Avenue between the lake and the Milwaukee River. (Photo courtesy of Frank Balistrieri.)

Mauro Gennaro came to Milwaukee in the late 1890s, after spending time in Argentina where he was a laborer. Previously, he was a fisherman in Sant' Agata, Sicily. In 1921, a painter misspelled his name on the side of a fruit truck owned by the family business, making it "Jennaro." The new spelling has subsequently been used by successive generations of Jennaros. He and his wife, Anna, lived on the northwest corner of Chicago and Jefferson in the Third Ward. Gennaro died at age 92, outliving his wife Anna by more than 20 years. (Photo courtesy of William A. Jennaro.)

Anthony Cannariato was born in Murphysboro, Illinois, in 1899, where his parents, Thomas and Louise Cannariato, emigrated earlier in the 1890s. The elder Cannariatos had left their home village of Allesandria della Rocca in the Sicilian province of Agregento to come to the midwest where Thomas got a job in the coal mines. When Anthony was 3 years old, the family returned to Sicily where he grew up. As a young man, Anthony fought in World War I as a soldier in the Italian Army, unaware that he had the option of joining the American armed forces. After the war, he came back to America with his new bride, Vincenza, to settle permanently. The couple first lived in Newark, New Jersey, where three of their four daughters were born. In 1936, the Cannariatos moved to Milwaukee, where Anthony's brother, Joseph, had settled and was manufacturing household bleach. Anthony subsequently worked at the Novel Wash Company until his retirement, living on Marshall Street on the East Side until his death at age 87. In addition to working full time, he cared for his four girls after the early death of Vincenza at age 37. (Photo courtesy of the Dentice family.)

THE UNITED STATES OF AMERICA

CERTIFICATE OF CITIZENSHIP

No. A-522910

Application No. A 18 962 705

·ORIGINAL·

Personal description of holder as of date of issuance of this certificate: Sex Male ; date of birth January 2, 1921 ; country of birth Italy ; complexion Medium ; color of eyes Hazel ; color of hair Brown ; height 5 feet 3 inches; weight 150 pounds; visible distinctive marks Scar near right eye

Marital status Married

I certify that the description above given is true, and that the photograph affixed hereto is a likeness of me.

*Peter Vella*

(Complete and true signature of holder)

Be it known, that - - - - - PETER VELLA - - - - - now residing at 2515 North Maryland Avenue, Milwaukee, Wisconsin having applied to the Commissioner of Immigration and Naturalization for a certificate of citizenship pursuant to Section 341 of the Immigration and Nationality Act having proved to the satisfaction of the Commissioner that s/he is now a citizen of the United States of America, became a citizen thereof on April 21, 1931 and is now in the United States.

Now Therefore, in pursuance of the authority contained in Section 341 of the Immigration and Nationality Act, this certificate of citizenship is issued this nineteenth day of January in the year of our Lord nineteen hundred and seventy and the seal of the Department of Justice affixed pursuant to statute.

Seal

The certificate of citizenship was the ultimate prize sought by members of Milwaukee's émigré Italian community. It meant that they had finally "arrived" and were being accepted into the broader American community. For his entire life, a proud Pietro Vella treasured the papers he received on April 21, 1931. (Photo courtesy of the Vella family.)

Paolo Puccio, a native of Sant' Agata, Sicily, always cut a dashing figure. He first came to America in the late 1890s, having to leave his oldest son Joseph behind because the child had an eye disease. For two years, Joseph lived with his grandfather Gaetano Calloroffi, a barber who doubled as a "dentist" by pulling bad teeth for his customers. Puccio returned from Milwaukee to Sicily several times to bring back others in his family, using income earned as a fruit dealer on Brady Street. In Italy, Puccio had married Calloroffi's only child, Teresina, and the couple had five children: Joseph, Tom, Fred, Rose, and Robert. (Photo courtesy of Betty Puccio.)

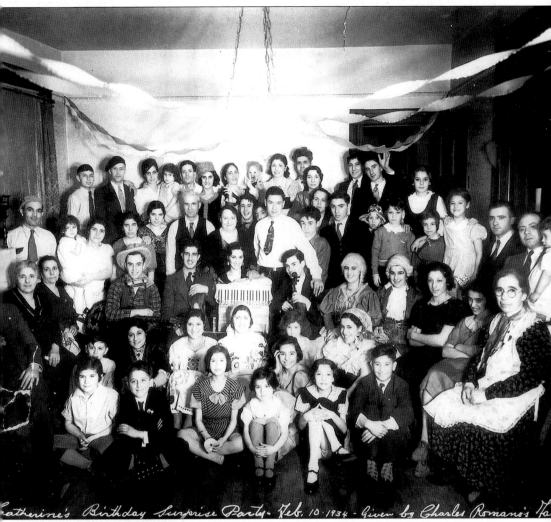

*Catherine's Birthday Surprise Party - Feb. 10 · 1934 - Given by Charles Romano's Fa*

Large home parties were popular throughout Milwaukee's pre-television days as the new émigrés made themselves at home in the city. Carpets were rolled up, streamers hung from the ceiling and friends and relatives wore funky costumes. Most family members even played instruments sas can be seen in this photo of Catherine Romano's surprise birthday party, February 10, 1934. In the crowd were Mary Mineo Winard, Pauline Puccio Cannestra, Joe and Jennie Puccio, and Lucille Romano (with wig, center right). With the harmonica, Joe Pelligrino is wearing the cowboy hat. Tony Romano is with the violin next to him. Catherine Romano has the accordion. Benedetta Romano is in the front row, far right. (Photo courtesy of Betty Puccio.)

Antoinette Demotto Mille poured a glass of wine for her husband, Amatore, at their South Side Milwaukee home in this 1930s-era photo. Antoinette, who was born in 1889, came to Milwaukee from Barre, in northern Italy, with her family in 1910. She and Amatore married and had children, living on the South Side while Amatore sold fruit. The couple eventually began selling sausages at street festivals in the old Third Ward, branched out to operate an Italian sausage stand at the Wisconsin State Fair, and owned several restaurants in Milwaukee with their son Mike. (Photo courtesy of Mike Mille, Jr.)

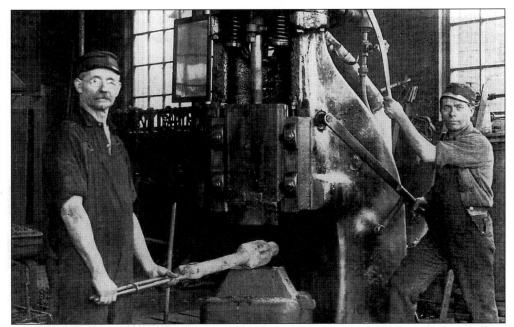

Eager for work, Italians provided the skilled backbone of Milwaukee's labor pool in the early 1900s. Vincent LaDuca (right) and Peter Paulas worked a piece of heavy equipment in 1914 at the Falk Corporation, manufacturers of couplings and other metalworks. (Photo courtesy of Mario A. Carini, Italian Community Center.)

Kids, kids, and more kids. In the early 1920s, papa Dominic Aveni held his son Fred on his lap, while Lou was seated in front of his mother, Dorothy. Dominic emigrated from Italy with his four brothers in 1903. (Photo courtesy of Terry Aveni.)

Nick DeRubertis was born in Salcito near Abruzzo in 1896 and came to the United States in 1922. For many years, he had a barber shop on Brady Street. He then moved to Farwell Avenue where Zaffiro's Pizza now stands. Later, DeRubertis opened a shop on Humboldt Avenue across from Sciortino's bakery, where Frank Balistrieri now runs an Italian gift shop. This photo was taken in 1922 when DeRubertis took off some time to visit Juneau Park. He died in 1976. (Photo courtesy of Rosemary DeRubertis.)

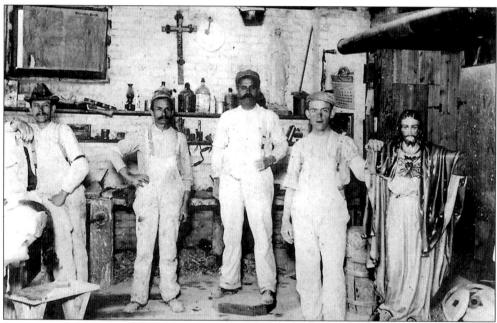

Pietro Piacentini (with his hand on his hip) was one of the workers at European Statuary and Art Co., a Bay View firm that employed numerous Italian emigrant craftsmen in the early 1900s. Their skills were greatly appreciated, contributing to the success of the firm, which had a national reputation for quality and precision. This shot from 1910 shows the men gathered near a statue they had made of Christ, one of the many produced over the years at the firm, now known as T.H. Stemper Co. (Photo courtesy of Mario A. Carini, Italian Community Center.)

Angie Bailey (left) and her aunt Sebastiana Novara Lamonte were dressed to go out on the town. Lamonte was the first teacher of Italian descent at the Detroit Street School in the Third Ward. Lamonte married and eventually moved to Florence, Italy, where her husband, Salvatore Lamonte, became an officer in the Queen's bodyguard. (Photo courtesy of Betty Puccio.)

Salvatore Lamonte married Sebastiana Novara Lamonte and the couple lived in Italy, where he was an officer in the Queen's bodyguard just before World War II. The Lamontes never returned to Milwaukee. (Photo courtesy of Betty Puccio.)

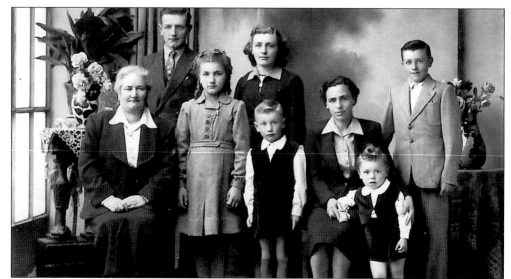

When Grandma Maria Adela Rossetto, 57, was preparing to leave her hometown of Asusa, Italy, for Milwaukee in 1950, her son and his family gathered for a farewell photo. Standing next to Grandma Maria (seated), was Serafino Rossetto, 38. Then, from left, are: Liliana, 13; Franca, 17; Dominic, 6; Serafino's wife Clelia, 36; Rodolfo, 4; and Graziano, 15. They would all join Grandma Maria in 1956, coming to America via the passenger steamer Cristofo Colombo,and then making their way to Milwaukee by train. (Photo courtesy of the D'Amato family.)

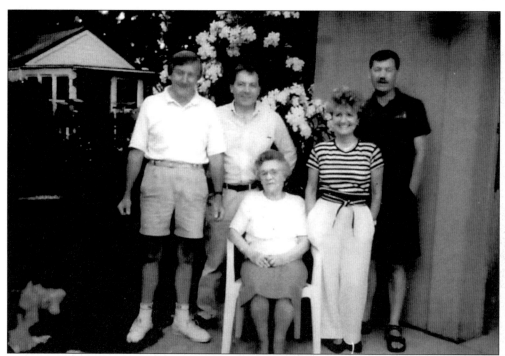

In 1996, the Rossetto family celebrated the 40th anniversary of their arrival in America. Standing behind Mama Clelia (from left) are: Graziano, Rudolfo, Liliana, and Dominic. (Photo courtesy of the D'Amato family.)

Onofrio D'Amato was a handsome 22-year-old merchant seaman when he left his ship in 1955 in Boston to stay to live in America. After he was unable to find work in that city, he made his way to Milwaukee, where his uncle Nick Storniolo had preceded him. Storniolo, his mother's brother, was a tailor at Gimble's Department Store at the time. Onofrio became a painter at American Motors. (Photo courtesy of the D'Amato/Rossetto families.)

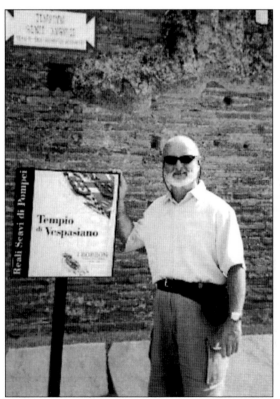

Joe Spasiano, retired corporate accounting systems manager of Miller Brewing Company, visited Pompeii on a trip back to his ancestral homeland of Italy and discovered that he might be related to Emperor Titus Flavius Vespasianu. The emperor was a reformer who took control of the Roman Empire after Nero. Spasiano was a native of Jamaica, N.Y., where his family operated a restaurant which opened in 1927. His paternal grandfather came from Rome and his grandmother from Sicily. Spasiano's mother was Irish and preferred calling her son "Joe," rather than his baptismal name of Salvatore. Spasiano came to Milwaukee in 1978. (Photo courtesy of Joe Spasiano.)

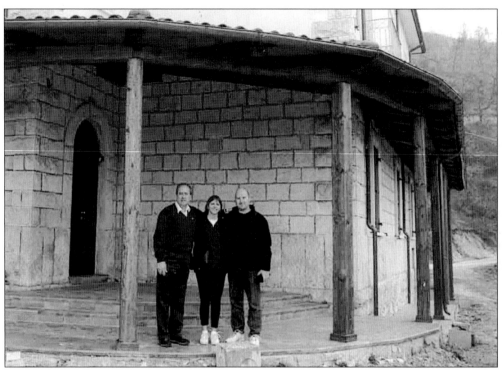

Sometimes you *can* go home. Croce Scipone and Bridgette and Peter DeToro stood on the porch of the DeToro family villa that was under renovation in 2004 in Abateggio, Italy. The lower photo shows the villa and its surrounding buildings on a picturesque hillside. Bridgette, a second year law student at Marquette, is married to Peter DeToro, third generation owner of DeToro Construction in Milwaukee. Croce, mayor of Abateggio, is a DeToro cousin. While in the village, the DeToros were also entertained by Giuseppe Gaudiosi, brother of Ubaldo and Helen Gaudiosi of Mequon. (Photos courtesy of Patti Keating Kahn.)

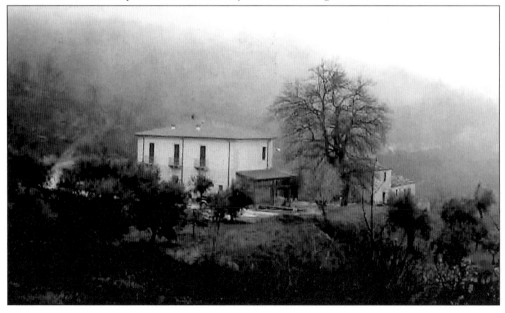

# *Two*
# CYCLE OF FAMILY LIFE

Weddings, births, baptisms, first Holy Communions, deaths—these are all part of the cycle of life within Milwaukee's Italian families. Sharing meals and wine through good times and bad, the families expanded throughout the city. The Italian neighborhoods were bustling, tightly-knit places where everyone knew everyone else, and many were related. Childhood friends became adult wedding-partners. As the community's elders died— before Giovanni Battista Guardalabene became one of the city's leading funeral directors in pre-World War I— wakes were held in private homes Then the Italian funeral home became another meeting place for families to gather to show solidarity.

This concept of "family" has always been the essential bonding element for the Lazio, Bartolotta, Nicola, Gentile, Sapanio, Tolosi, De Palma, Martinelli, Magestro, Lendarduzzi, and other Italian clans who call Milwaukee home. No one minds if everyone talks at once around the holiday dining room table! It's part of being "family."

Snapshots of this Italian Milwaukee are fun to peruse: Charles Corrao, his brother, Joseph, and their baby sister, Josephine, playing in a homemade wagon outside their home on East Chicago Street around 1920; Camillo and Rose Ingrilli proudly showing off their beautiful family of wide-eyed youngsters in 1923; Lena D'Amico, a beautiful bride for husband, Tom, when they married in 1926; the daughters of Carmen Germane standing on the porch of their Third Ward home in the 1930s; a perky bonnet and wide dress made for a picture-perfect Josie Giuffre (Giuffre) Crosariol in 1930.

Grandpas and grandmas snuggled babies. Parents administered discipline. Relatives came and went. New arrivals from Italy needed to be mentored. Fathers and mothers labored hard to care for their children. There were church…school…work…and social gatherings. Yet hearth and home have remained primary. That is where the heart can always be found.

Milwaukee Braves shortstop Johnny Logan (center) was in top form and was made part of the family when he stopped by to give a talk at a Holy Name Society meeting at Pompeii church in the mid-1950s. Joining him for a photo opportunity were Joe Busalacchi (left) and Sam Busalacchi (right). (Photo courtesy of Rose Mastrogiovanni.)

23

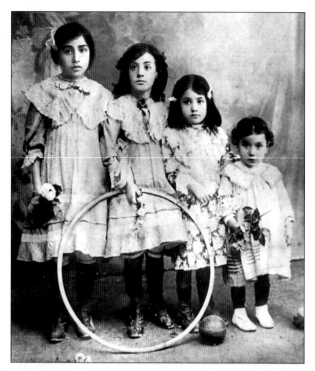

In 1908, the Pirelli sisters were all spiffed up for their portrait. From left are Louise, Rose, Anna, and Josephine. Rose Pirelli was the mother-in-law of Mrs. Rita Jennaro, wife of attorney William A. Jennaro. (Photo courtesy of William A. Jennaro.)

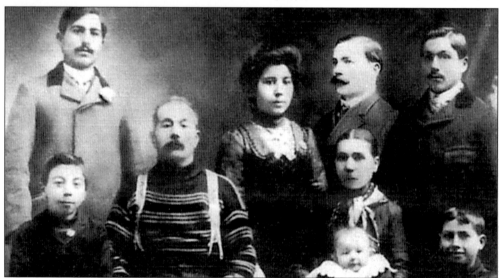

On June 24, 1893, the Feast of St. John, Giovanni Busalacchi arrived in Milwaukee to start a new life. He had left his parents and siblings back in Sant' Elia, Sicily, and vowed to bring them to America when he had made enough money. By 1896, Giovanni had brought over his parents, Maria and Andrea Busalacchi, and his brothers: Antonino, Giuseppe, Gaetano, and Stephano. After Giovanni returned to Sant' Elia to marry Francesca Tarantino, he came back to Milwaukee with his new bride and his sister Giuseppina. Other family marriages quickly followed: in 1906, Antonino married Vincenza Bellante; in 1908, Giuseppina married Antonino Busalacchi; in 1914, Giuseppe married Diana Cianciolo; and in 1917 Stephano was wed to Maria Bellante. This undated photo shows the extended family. (Photo courtesy of Frank Balistrieri.)

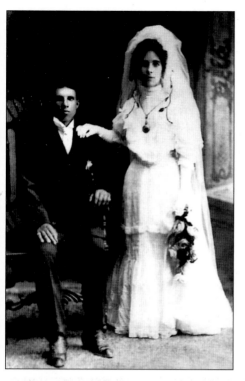

A large bouquet of roses was an integral part of the ensemble for Benedetta Novara when she married Pasquale Romano in 1907. The two had known each other in Sicily but were not married until they moved to Milwaukee at the beginning of the 19th century. One of their daughters, Jennie Puccio, became the first woman president of the Italian American Federation, and a president of UNICO. (Photo courtesy of Betty Puccio.)

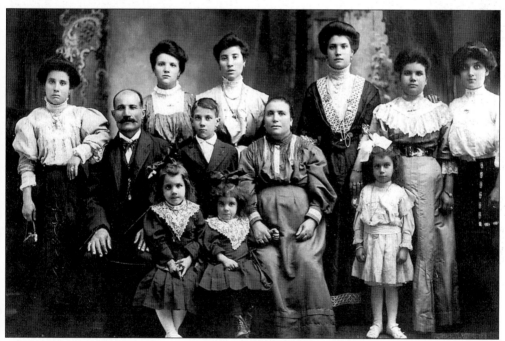

The Balistreri family in 1912 consisted of brood of lovely children and their proud parents. Standing were (from left) Rosa, Giuseppina, Stefana, Francesca, Caterina, and Aurelia. Seated in the middle were Gaetano, Giuseppe, and Antonina. The little girls in front were Maria, Petrina, and Catherine (daughter of Caterina). (Photo courtesy of the Vella family.)

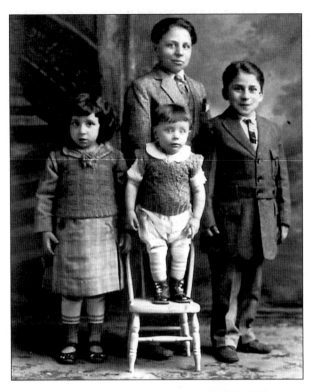

The Aveni youngsters gathered for a photo in 1928, with 12-year-old Lou standing in the rear, flanked by his brother Fred, eight, and sister Miriam, six. Tony stood on a chair. Their sister Josie was not yet born. Lou became co-owner of the Sullivan Construction Company, and Tony helped design the Bradley fighting vehicle and worked for Lockheed Martin Missile & Space Company. (Photo courtesy of Terry Aveni.)

The Nardelli family was dressed in its Sunday best for this old photo. Seated from left were Celia, Joseph, Marie, Louis, Joseph Sr., and Leo. In the back were Frank and Alfred. Papa Joseph worked in the iron mines of Wisconsin and the Upper Peninsula when he first emigrated to the States, along with his brothers, Frank, Alfred, Leo, and Louis. In the early 1930s, he married the lovely Celia Rigotti of Sporeminore, a village in Trentino. The couple moved to Milwaukee when the mines closed and Joseph became a laborer for the city, dying in 1944. Celia died in 1963. Young Leo became the father of Milwaukee alderman Thomas Nardelli. (Photo courtesy of Thomas Nardelli.)

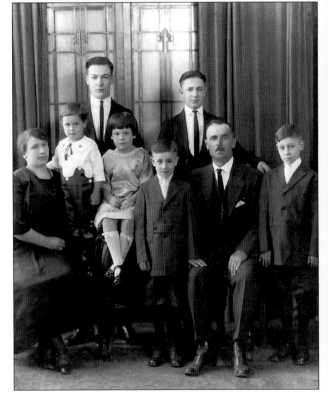

Sebastiano and Angela Attinello Mastrogiovanni posed in 1922 with their sons: one-year-old Salvatore and three-year-old Joseph. The couple emigrated from Santo Stefano Di Camastra in Messina province in 1900. They were married on December 13, 1919, and had nine children. Mastrogiovanni worked at Milwaukee Steel and Grede Foundry. (Photo courtesy of Rose Mastrogiovanni.)

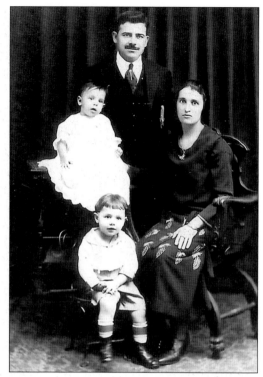

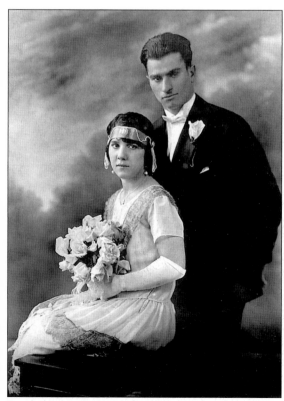

Maria and Giuseppe Balistreri were married on November 9, 1925, after eloping to Buffalo, New York. Returning to Milwaukee, Balistreri continued working as a carpenter, building the family home at 2219 N. Weil Street in 1926. The couple's children were Rose, Tom, Antonina, Tony, Frances, and Anna Maria. The elder Balistreri was 14 years old when he came from Sant' Elia, Sicily, in 1912. Maria was born in Milwaukee, the daughter of Gaetano and Antonina Balistreri. Balistreri died in 1976, and his wife in 2000. (Photo courtesy of the Vella family.)

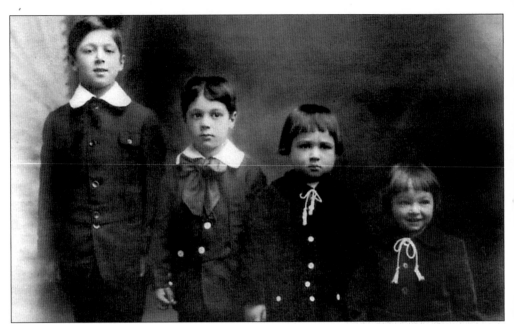

The four Diliberti brothers posed with various degrees of seriousness in 1917. From left were Rosario, Phillipe, Salvator (Sam), and Giacomo (Jim). Their dad Pietro and mom Grazia Trupiano Diliberti were born in Sicily, coming Stateside in the early 1900s.

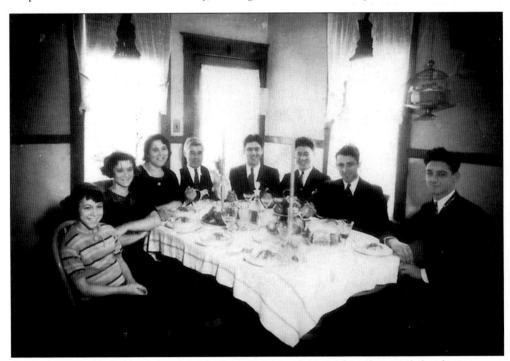

Around 1935, the Diliberti brothers had grown up and are gathered around the dining room table at the family home at 3418 W. Scott Street for a Christmas dinner with their parents and sisters. From left are Providence (Provi), Virginia, Mama Grazia, Papa Pietro, Rosario, Phillipe, Salvator, and Giacomo. (Photos courtesy of Dan Diliberti.)

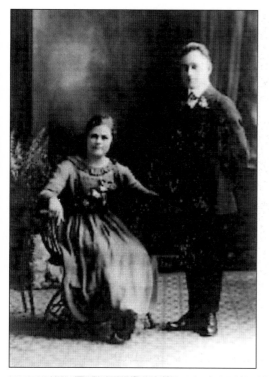

Antonio Piacentini and Catherine Wawrzon paused for a wedding photo February 23, 1923. Piacentini was born in 1891 in Milwaukee, a first-generation Italian who worked with his father at a statue factory in Bay View. Among their projects was decorating the ornate interior of the Oriental Theater on the city's East Side. (Photo courtesy of Faith O'Connell.)

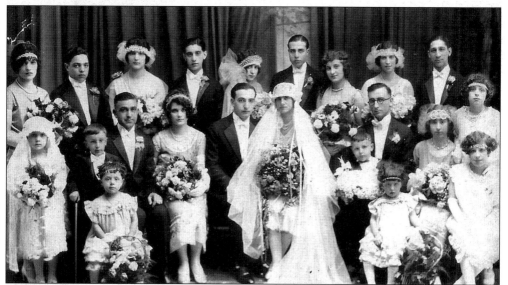

Establishing a family was a priority for young Italian-Milwaukee men and women. The marriage of William and Florence Vitucci Jennaro (center) took place in 1926. Florence, daughter of bar owner/King of Little Italy Michael Vitucci and his wife Rose, was called "The Princess of Little Italy." The wedding made the social columns of the local paper. To her left was her brother Angelo and sister Grace. To William's right was maid-of-honor Francis Spicuzza. The little boy on the left side was Michael Vitucci, nephew of the bride. The two girls in the front row on either side of the wedding couple were twin sisters, Ann and Margaret Jennaro, the daughters of George and Sara Jennaro. (Photo courtesy of William A. Jennaro.)

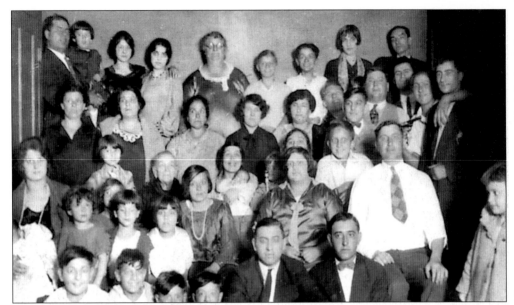

Milwaukee's Italian families never need much of an excuse to get together. In 1926, the Balistrieris, Picciurros, and Gaglianos assembled to celebrated the baptism of baby Mary Balistrieri, barely seen in the middle of the clutch of other relatives. She was being held by her mom, Bedetta Picciurro Balistrieri. Her father, Johnny Picciurro, operated Pitch's Restaurant, still a popular East Side eatery. (Photo courtesy of Frank Balistrieri.)

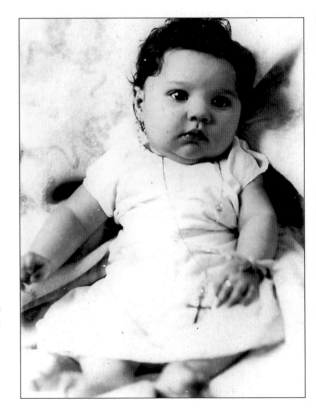

Rose Balistreri Vella was six months old when she was baptized in March of 1927 at Our Lady of Pompeii Church in the Third Ward. Her parents were Maria and Giuseppe Balistreri. (Photo courtesy of the Vella family.)

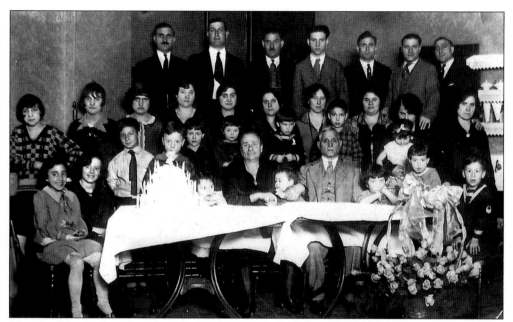

The Sanfelippo family gathered around matriarch Giuseppena and patriarch Pietro in a gathering in 1927. The Sanfelippo elders came to Milwaukee in 1910, where Pietro owned a tavern called the Brite Spot on Detroit and Jefferson. They had three boys and three girls. (Photo courtesy of Geraldine Accetta.)

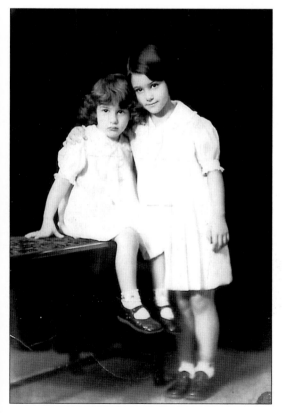

Tootsie Puccio Blend (left) and Pauline Puccio Cannestra were the perfect sisters in this 1932 portrait. (Photo courtesy of Betty Puccio.)

31

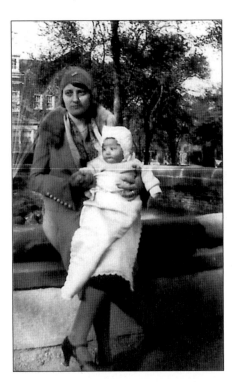

Zina DeRubertis and her daughter Rosemary enjoyed a pleasant afternoon in Watertower Park near St. Mary's Hospital in 1934. DeRubertis was born in 1906 in Rome and died in 2002. In addition to caring for her family, she was a seamstress for Florence Eiseman dress manufacturing and was very active in the Italian community. (Photo courtesy of Rosemary DeRubertis.)

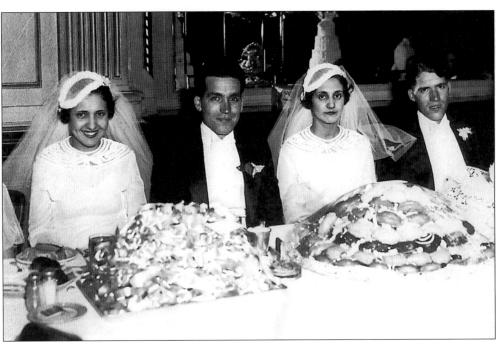

This double wedding on October 26, 1935, united (from left) Rose and Paul Accetta and Jack and Ida Accetta. The women were the Storniolo sisters and the men were brothers. After several years working out of Commission Row, the Accetta family opened the Village Fruit Market on Silver Spring Drive. (Photo courtesy of Geraldine Accetta.)

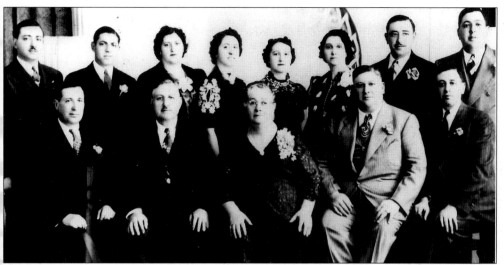

The Frank and Rose Balistrieri family gathered for a portrait in 1939. From left to right are: (front row) Joseph Balistrieri, Frank Sr., Rose, Frank Jr., and Peter; (back row) Dominic, Carlo, Mamie, Mary, Rose, Frances, Salvatore, and Tom. The family lived on Miwaukee's Lower East Side. Frank Sr., was an independent rubbish contractor for the city of Milwaukee. He first used horses to haul the wagons and became mechanized around 1945. Frank Jr. also had more than 100 head of horses, traveling around the state to purchase the best looking Clydesdales, Percherons, and other muscular breeds. Many won pulling contests at the Wisconsin State Fair. (Photo courtesy of Frank Balistrieri.)

Pietro Piacentine was a doting grandfather keeping a close eye on his grandson Thomas O'Connell in this photo dated May 27, 1945. Tom is a retired Milwaukee Public School teacher and baseball coach. Grandpa Pietro and his brother Tony were artisans at the old European Statuary factory in Bay View, now T.H. Stemper's. (Photo courtesy of Faith O'Connell.)

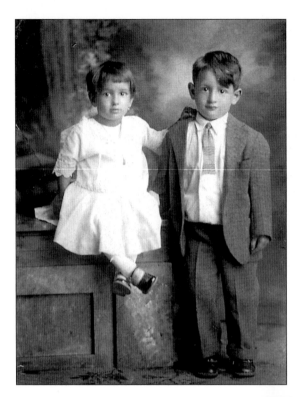

Taking a day out from neighborhood play to star in a family photo, Frank J. Balistrieri, who was 3 or 4 years old at the time, stood alongside his sister, Rose Marie, 19 months. (Photo courtesy of Frank Balistrieri.)

Peter Balistrieri was barely a year old in 1946 when he donned his dad's hat, picked up a pipe, and was ready for a snifter. Peter did grow up and become one of the city's best known barbers. He purchased Nick's Barber Shop at 1520 E. Capitol Drive from Nick D'Amato, who worked in the shop for 30 years. (Photo courtesy of Frank Balistrieri.)

Caterina Dentice stood in the backyard of her home at 1425 Jefferson Street, some time in the 1940s. For 50 years before he died, her husband Giuseppe was a street sweeper. After his death, Caterina wore the traditional black, like most Italian widows. As a youngster in Porticello, she was hired as a servant to help with the cooking for a noble Palermo family. Once in Milwaukee, she made pastries for weddings and baptisms. Her children and their friends waited eagerly for the first cookie samples when they came out of the oven. (Photo courtesy of Frank Balistrieri.)

Everybody should have a grandma like Calogera (Gloria) Olla, who lived with her daughters Bessie Olla, and Therese Olla Glorioso and her family, on North Murray Avenue, just north of Locust Street. Grandma Olla was born in Sicily and came to Milwaukee as a young woman. (Photo courtesy of Joe Glorioso.)

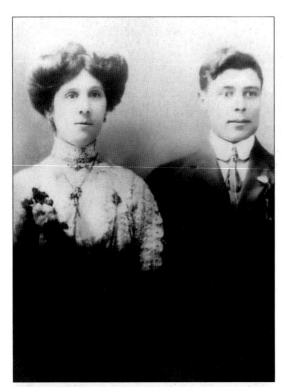

Pietro Diliberti and his new wife, Grazia Trupiano, were a striking couple on their wedding day, February 27, 1908. Pietro had emigrated to Milwaukee from his hometown in Balistrate, Sicily, in 1903, but returned in 1908 to marry his lady love. The Dilibertis then came back stateside to settle on Milwaukee's South Side, where he and Grazia raised their family. Diliberti worked as a masonry contractor. (Photo courtesy to Dan Diliberti.)

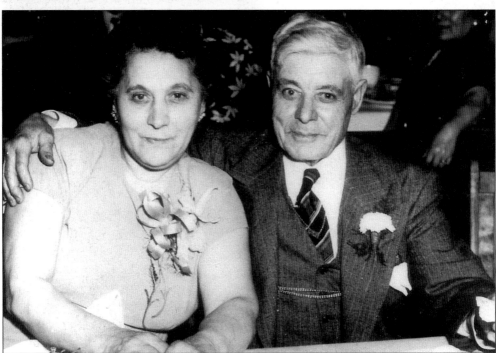

Pietro and Grazia Trupiano Diliberti celebrated their 50th wedding anniversary in 1948, surrounded by family and friends. The couple lived for years at 3418 W. Scott Street (Photo courtesy to Dan Diliberti.)

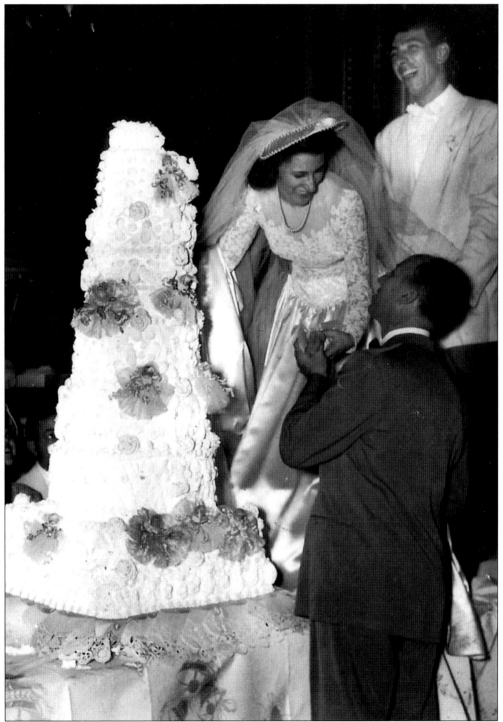

Laughs went around Jefferson Hall as Pauline Puccio gave the first piece of her wedding cake to dad Joe Puccio, as new husband Joseph Cannestra joined in the merriment. The young couple were married September 25, 1948, at St. Rita's Church. (Photo courtesy of Betty Puccio.)

Joe Puccio was joined by his father and brothers in 1948 for his 25th wedding anniversary in what was the city's first Italian center: Casa Colombo ("House of Columbus") on Cass Street. Joe is in the white tuxedo. From left are: Tom, who helped their father in the fruit business; Papa Paolo; Bob, owner of the P&P Distributing Company, an amusement games business on North Holton Avenue; and Fred, who had a barber shop in Cudahy. The latter always offered good tips on horse racing, as well as giving great haircuts. Joe was married to Jennie Romano Puccio. (Photo courtesy of Betty Puccio.)

It was a beautiful day for a stroll along Wisconsin Avenue in 1953, as Anna Tarantino and her daughter, Rose, then 16, went on a shopping trip. Rose eventually married Peter Papia and the couple managed the Papia Upholstery Shop on Lincoln and Howell for 25 years. (Photo courtesy of Anna Tarantino SanFelippo.)

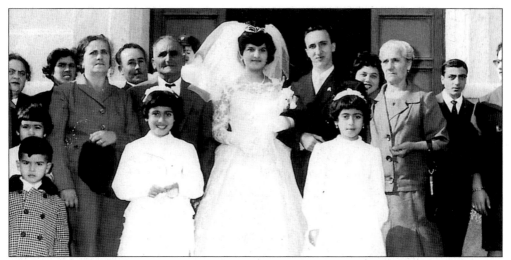

The wedding of Girolama (Mimma) Orlando of Porticello and Joseph A. Megna of Milwaukee was a big family affair on November 26, 1962, in Sicily. Mimma was a mere 16, flanked on the right by her mother Rosalia and father Salvatore. The flower girls in front were twin sisters, Agata and Anna. The couple met when Joe visited relatives in Sicily while still a student at St. Francis Seminary. He revisited a short time later and became engaged to Mimma. Typical of such family links in those days, Joe was Mimma's mother's first cousin, and her mother's mother was her father-in-law's sister. (Photo courtesy of Girolama (Mimma) Megna.)

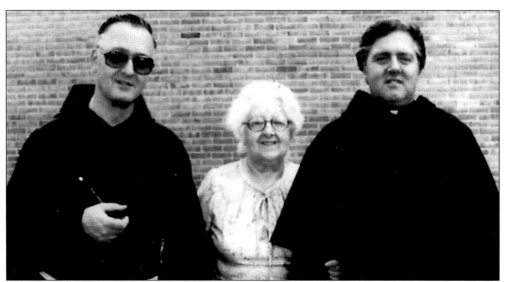

Having sons in a religious order can certainly warm a mother's heart. Mrs. Julia Sparacino was flanked by Capuchin Brother Francis Mary (Anthony Sparacino) and Augustinian Brother Lawrence (Raymond Sparacino). The Sparacino family grew up on Milwaukee's East Side and attended St. Rita's. For years, Francis Mary was a tailor for the order, making 7,600 habits over 21 years for his fellow Capuchins at his workshop at Mount Calvary Seminary. The Sparacinos' father was from near Palermo and his mother was from Lucca. Brother Francis Mary entered the Capuchins on September 5, 1949, following his younger brother's lead. However, Lawrence switched to the Augustinians, eventually becoming his community's administrator in Chicago. A middle brother, Andrew, remained in the Marines. (Photo courtesy of Three Holy Women Parish.)

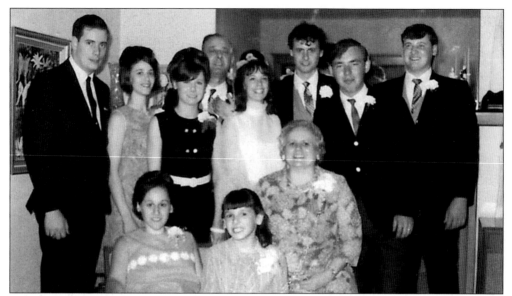

Weddings have always been big affairs in Italian families. When Dan Diliberti and his wife Ann were married on June 7, 1964, everyone gathered around. From left to right are: (seated) Jane Diliberti Morris, Anne Wied, and Ruth Diliberti; (standing) Terry Morris, Pat Diliberti Eddings, Marge Diliberti Timcik, Jim Diliberti, newlyweds Ann and Dan, Dick Eddings, and Mike Diliberti. (Photo courtesy of Dan Diliberti.)

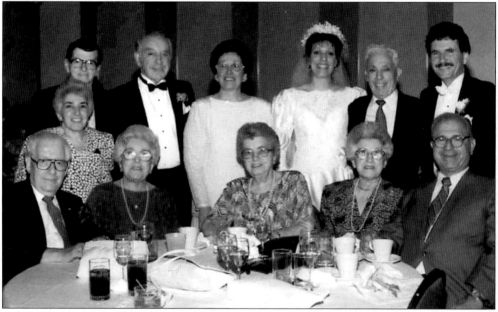

A large group gathered for the May, 1987, wedding of Rosino Crivello and Bobby Giannos. From left to right are: (front row) Anthony Sardina, Grace (Crivello) Sardina, Concetta (Bartolone) Crivello, Rosalia (Crivello) Bartolone, and Salvatore (Sam) Bartolone; (back row) Richard Jones, Vincent Crivello, Josephine Crivello, Rosina Crivello Giannos, Alex (Leo) Crivello, and Bobby Giannos. Mary (Crivello) Jones was in the middle. (Photo courtesy of Brian Witt and Mary Crivello Witt.)

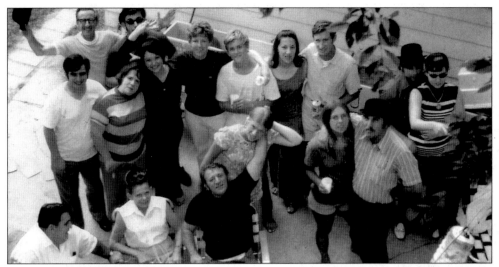

There was always fun, food and refreshing beverage whenever the Aveni family gathered. This gathering in 1971 was held in the backyard of Tony Aveni's home in Menomonee Falls. From left to right are: (back row) Fred Komar, Terry Atteberry (with hat), Patrina Aveni, Katrina Aveni, an unidentified neighbor, Barbara Cuthbert, Scotty Cuthbert, Terry Timms, and Sharon Timms; (second row) Mike Aveni, Josie Aveni Romari, Kathy Aveni, and Lou Aveni. Laura Aveni was being hugged by Anthony (Tony) Aveni. Seated was the family patriarch, Fred Aveni and his wife, Millie. In front were Lillian and Louis Aveni. (Photo courtesy of Terry Aveni.)

Tom Mussoline was just 14 years old in 1988, in the 8th grade at DA Harmen Junior High School in Hazelton, Pennsylvania, when he first visited Milwaukee. He moved to the city in 1998 and taught music and physical education to all nine grades for one year at Corpus Christi school on Milwaukee's Northwest side. Mussoline then taught computer graphics for four years at the University School of Milwaukee and went on to become a GE Healthcare manager in Waukesha. He has four older brothers: Steve, Rocco III, George, and Frank. Mussoline's father, Rocco Mussoline Jr., is a retired school principal. His mother Mary Ellen was a housewife who passed away in 1992. Mussoline was married in 2004 to Nell O' Connor Gonring. His grandfather, Rocco Mussoline Sr., was a coal distributor in Hazelton, and his grandmother Louisa was a housewife who tended to their four children: Rocco Jr., Catherine, Michael, and Mary Louise. His great-grandmothers were from Paterno, Italy, and Hazelton, and his great-grandfathers were from Calabria and Mosca Nova, Italy. (Photo courtesy of Mary Louise Mussoline.)

Mary Crivello wore her Italian costume to Heritage Day celebrations in 1972 at St Joan Antida High School. Mary grew up on the Italian East Side of Milwaukee, one of four children of Vincent and Josephine Crivello. Mary married Brian Witt, the Irishman of the Year in 2004 She graduated from Alverno College. Her brother Frank (married to Nancy Giamo Bridich) became a graduate of Beloit College and received a dual masters from Cambridge University in economics and social studies. Brother Anthony was a Tony award winner for Best Supporting Actor in a musical in 1993. And sister Rosina (married to Bobby Giannos) is a longterm employee at Columbia St. Mary's Hospital. The Crivello family originated in Porticello, Sicily. (Photo courtesy of the Crivello family.)

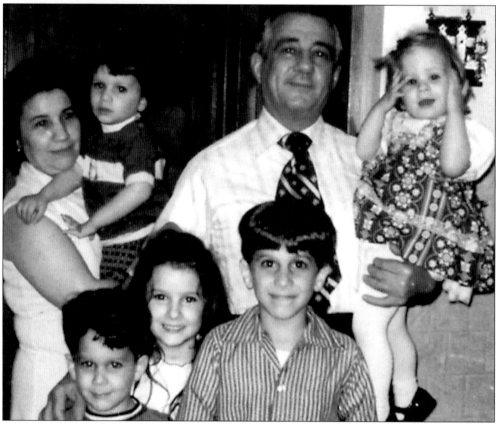

Easter in 1973, at the Shorewood home of John and Nina Vella Zizzo, always meant armfuls of kids and grandkids. Rose Vella holds son Anthony, while her husband Peter holds their granddaughter Andrea Katzke, whose mother is Mary Vella Katzke. In the front row were the Vellas' son Damian, granddaughter Angela and son Paul. The Zizzo family remains proud of its deep Italian roots. (Photo courtesy of the Vella family.)

# *Three*

# NEIGHBORHOOD FRIENDS ARE FOR LIFE

*Milwaukee's Third Ward holds a special place in the heart of the city's Italians. The area south of downtown was originally swamp that was filled in by the city's early settlers. The Germans and Irish were first to settle there, working on the docks and quickly gaining access to Milwaukee's fire, police, and business communities. Most of the Irish left the neighborhood after a disastrous fire in October, 1882, which destroyed 440 buildings and killed several persons.*

*Reconstruction of warehouses and other buildings quickly began, however, with newly arriving Italians settling in the district. Most were from southern Italy and Sicily, departing their homeland in search of better jobs. Commission Row in the Ward became the hub of Milwaukee's fruit and vegetable market. Francesco and Valentino Nanni, brothers from the province of Lucca, were the first two Italians known to have lived in the Third Ward. According to the 1857 city directory, they made plaster of Paris figures, living at 138 Huron Street. The first known Sicilian to settle in the Ward was Augustino Catalono in 1884. By 1910, he and his four brothers had one of the largest wholesale produce distributorships in the area.*

*The Italians built their first church, the Blessed Virgin of Pompeii, in 1904. The "Little Pink Church" remained a hub of the community until it was demolished in the 1960s to make way for the I-794 freeway. In 1984, the National Register of Historic Places named ten square blocks of the old Ward as an historic site. The late Milwaukee Sentinel columnist Jay Joslyn talked with Mrs. Teddy Mazza in 1979 about that long-ago neighborhood. "When we drive past the Van Buren Street exit of the First Wisconsin Center parking structure, I say to Teddy, 'Hey, we're driving through our bedroom,'" she recalled.*

*Today, many of the remaining buildings there have been converted into loft apartments, trendy bars, and shops. Even with gentrification, a major touch of Italy remains. Led by a succession of hardworking presidents such as George Menos and Mario A. Carini, the Italian Community Center remains The Neighborhood for the Italians of Greater Milwaukee. The ICC site is at the intersection of Jefferson and Chicago streets, where there were once houses and small businesses. What still brings the old neighbors back "home," is the ICC's Il Grande Carnevale, cooking classes, New Year's Eve parties, bingo, senior luncheons, and reunions. The first head of the ICC was Anthony C. Macchi.*

*Brady Street on Milwaukee's East Side was also another hub of Italian activity. In 1974, The Milwaukee Journal photographers John Biever and Ron Overdahl roamed the neighborhood, recording what they saw. Surrounded by grandchildren, Tony Perlongo relaxed on his front porch, cigar clomped tightly in the center of his mouth. Mrs. Lucia Damiano watered her lawn. Frank La Barbara weighed links of Italian sausage. Tom Busalacchi bagged groceries for Jimmy Albano. Names are still remembered, although the faces are now gone: Sam D'Amato, D'Amato Grocery, Peter Sciortino (of Sciortino's Bakery), and Pete Colla (Colla's Fish Market).*

*But there still are reminders of Italian heritage: the Roman Coin bar, Pitch's Lounge & Restaurant, Fazio tailors/cleaners, Glorioso's grocery, and other shops and services.*

*Numerous Italians, primarily from the Marches region, as well as from Piedmont, Liguria, Venice and other northern Italian areas, settled in the South Side neighborhood of Bay View, where factories, rolling mills, and a statuary company offered employment. This community centered around East Russell Street, home of Club Garibaldi, and Groppi's grocery store, one of the oldest Italian food stores in Milwaukee. The Groppis were from the Tuscan town of Lucca. When Mario Groppi, one of the store owners, died in 2002, the store was purchased shortly afterwards by the Sendik family of grocers.*

*The neighborhoods remain alive in spirit. And friends stick together.*

For years, the booming voice and guitar music of Tomaso Balistrieri was a regular fixture at Third Ward social gatherings. Balistrieri was born in Sicily in 1874 and became a fisherman. The villagers on shore could hear him singing even while out to sea casting his nets. Balistrieri came to Milwaukee at the turn of the century, dying here in 1940. When he was a young man, he once performed at a reception for opera star Enrico Caruso, when the singer visited Milwaukee. Caruso was so impressed with Balistrieri's voice that he tried to encourage the young man to take singing lessons and even promised to underwrite his studies in Italy. Balistrieri rejected the offer, preferring to stay with his family in Milwaukee. When the two shook hands after their conversation, Balistrieri discovered that Caruso had slipped him $100. (Photo courtesy of Frank Balistrieri.)

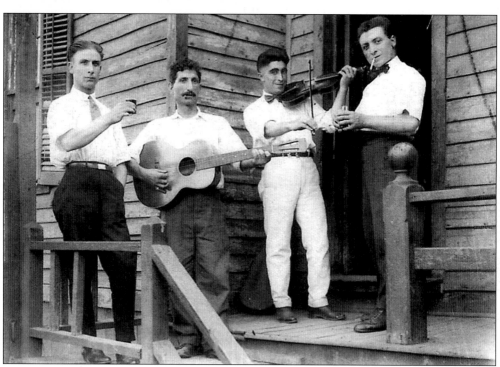

Music was an inexpensive way to entertain in the old days, with many amateur performers ready at any time. In 1922, an unidentified friend offered a toast to, from left to right, Anthony Lalli, Nick DeRubertis, and Salvatore Lalli. (Photo courtesy of Rosemary DeRubertis.)

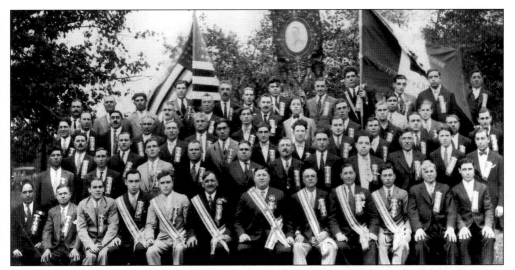

On a bright summer day around 1929, members of the Prince Umberto Society gathered in Crackerjack Park along the Milwaukee River, just north of Capitol Drive on Humboldt at Milwaukee's city limits. The society memorialized the prince's grandfather, King Umberto, who was assassinated by an anarchist named Gaetano Bresci in 1900. The prince, who was born in 1904, succeeded his father, Vittorio Emmanuelle II, to the throne in 1946. He ruled for a year before the country voted to abolish the monarchy and become a republic. Umberto eventually settled in Portugal and never returned to Italy, much to the disappointment of his supporters in Milwaukee. (Photo courtesy of Frank Balistrieri.)

With Father Corrado Ostorero by their side, the Holy Name Society of the Blessed Virgin of Pompeii Church paused for a portrait in 1929. The group was organized in 1927 with Cosmo Catalano the first president. Other presidents included Steve Carini, Salvatore Patti, Salvatore Cannizzaro, Frank Gordetto, Charles Mazza, Steve Balistreri, Tony Maglio, Dominic Carini, Sam T. Busalacchi, Alfred Maglio, Joseph Caminiti, Joseph Catalano, Sam Purpero, and Sam Catalano. Under the supervision of Fr. Joseph Vicentini and the men of the Holy Name Society, the Pompeii church hall was remodeled in 1962. Many successful "smokers" were subsequently held in the new space. (Photo courtesy of Three Holy Women Parish.)

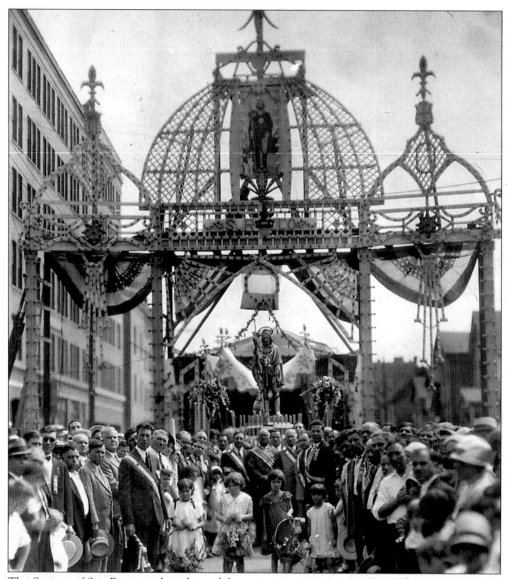

The Society of San Rocco gathered to celebrate its patron in August 1930. The scene, with the elaborate arch over the street and the statue of the saint with his ever-present dog, is facing north on Jackson Street at the intersection of Detroit. The white-haired man wearing the sash and standing in front of the statue is Mike Vitucci, dubbed "King of Little Italy." Vitucci came to Milwaukee in the early 1900s via Brazil, where he had been a plantation manager. He was originally from Bari, an Adriatic seaport. Vitucci operated Mike's Tavern on the northeast corner of Jefferson and Chicago streets. Because he could speak English and was well connected to Milwaukee's political establishment, he helped emigrés secure jobs, and on at least one occasion acted as a mediator in a dispute that arose within the Third Ward, between members of the "Black Hand." When these litigants came by the tavern for peace talks, Vitucci's wife, Rose, confiscated their guns and stored them in the pantry until the meeting concluded amicably. When Vitucci died in 1938, his honorary pallbearers included Senator Robert M. La Follette Jr., Governor Philip F. La Follette, two judges, a police captain, and the district attorney. (Photo courtesy of William A. Jennaro.)

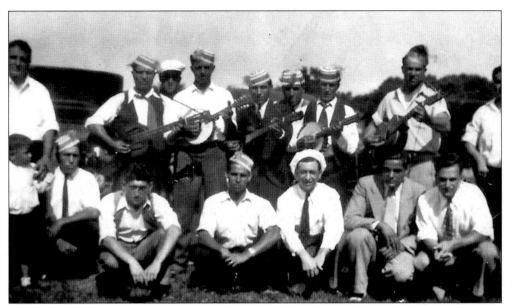

Men belonging to the American-Italian Alliance meet at Crackerjack Park on Milwaukee's far north side in 1933 to picnic, talk, and play music. Among the crowd were Frank Balistrieri (wearing white hat in front) and his sons Joe and Frank, Jr.; plus, Pietro Balistreri (note the different spelling), Pepino Seidita, Pasquale Migliaccio, Ted Asti, Sam Aiello, Pedo Valone, John Guardalabene, and Ben DiSalvo. The alliance clubhouse was on Cass Street, south of Juneau. (Photo courtesy of Frank Balistrieri.)

The staff and directors at the Blessed Virgin of Pompeii Church in the late 1930s included, from left to right, Father Louis Riello (assistant), Father Gregory Zanoni (pastor), Father Louis Donanzan (assistant), John Cianciolo, and Vito Marchese. (Photo courtesy of Three Holy Women Parish.)

A group of Third Ward pals piled into an Auburn sports car driven by Augie Maniaci in the early 1930s. One of ten boys in his family, Maniaci worked at the family restaurant, the Canadian Club, on Jefferson Street in the Third Ward. His brother Tony stood on the running board on the driver's side. Cousin Joe Maniaci is on the other side of the car. The other men are not identified. (Photo courtesy of Frank Balistrieri.)

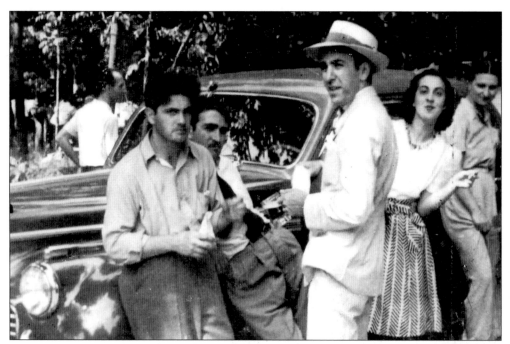

On a warm summer day in this undated photo, Mike Mille Sr. (in hat and suit) and his wife Alice gathered with friends in a wooded Milwaukee park. The Mille family has owned several restaurants in the Milwaukee area, and have been operating an Italian sausage stand at State Fair Park since 1929.

The Puccio men gathered on Lake Michigan's waterfront in the late 1930s to enjoy a summer afternoon. It was still a formal enough affair to wear coats and ties. Pictured in the back are, from left to right, Paolo Puccio, Joseph P. Puccio, Tony Puccio, unidentified, Joe Puccio, and another unidentified man. Kneeling are an unidentifed man (left) and Fred Puccio. Both Tony and Joe Puccio were visiting from Boston. (Photo courtesy of Betty Puccio.)

The Milwaukee lakefront has long been the place to gather, especially for the city's body builders, who always liked to show "their stuff" to the passersby. In 1940, Pietro Vella was 20 years old, and one of a group of young Italian men who lifted weights and did their various routines to the admiring glances. (Photo courtesy of the Vella family.)

In August, 1942, the guys gathered at Charlie Sciurba's house on Milwaukee's South Side. Pictured from left to right are: Angelo Maniaci, Ted Seidita, Tony Guardalabene, Frank J. Balistrieri, Louie Seidita, and Frank S. Balistrieri. Louie was blind and eventually managed the newspaper and tobacco concessions at the Federal Building and City Hall. Tony became a mortician. Ted operated New Deal Foods marketplace at the corner of Ogden and Farwell. Angelo worked for his father in the old Canadian Club tavern in the Third Ward. At the time, Frank Jr. was an auditor for the Internal Revenue Service, but he moved on to operate his own restaurants. Frank Sr. worked for his father and uncle in the refuse hauling business. (Photo courtesy of Frank Balestrieri.)

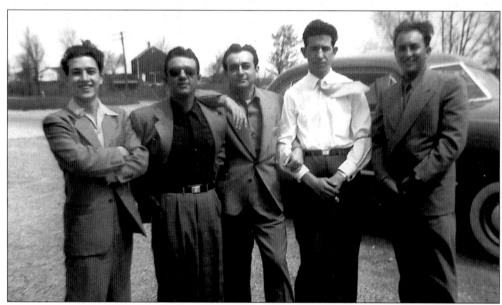

Best buddies from Milwaukee's East Side gathered in 1948 for a group snapshot. Pictured from left to right are as follows: the dapper Tom Vicini, Peter (Pietro) Vella, Nick D'Amato, Joe Apparito, and Joe Dentice. Vicini went on to work at the Wisconsin Gas Company; D'Amato became a barber; Dentice ran a produce firm; and Apparito was both a baker and mason. Vella worked as mason for the Milwaukee Public Schools. (Photo courtesy of the Vella family.)

50

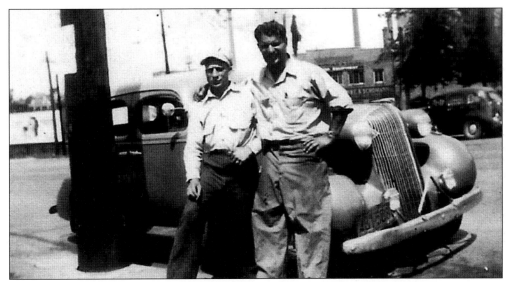

Carl Dentici (left) and Tudy SanFelippo were set for a drive around town in 1940. The two young men stood by their car outside a filling station built in 1935 by brothers Frank Jr. and Joe Balistrieri, on the corner of Van Buren and Brady streets. Dentici worked in the station and SanFelippo was a teamster for the Balistrieri family's refuse-hauling business. (Photo courtesy of Frank Balistrieri.)

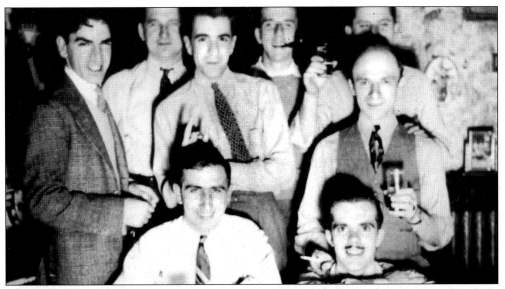

Mike Mille, Sr., (standing third from left) met a bunch of unidentified pals for drinks and cards. In 1932 when he was 16, Mille started working for his parents, Antoinette and Amatore Mille, selling Italian sausages at the Wisconsin State Fair. In 1947, helped by his parents, he and his wife Alice opened Mille's Bar-B-Que Restaurant at 82nd and Greenfield, thus becoming one of the first South Side eateries to sell pizza. Partnering with Angelo Marco in 1955, Mike opened Michaelangelo's Restaurant at 62nd and Fond du Lac. In 1966, the friends added a motel to the place, calling it the Inn America. In the 1960s, Mike also ran a restaurant in Menomonee Falls. In 1976, he helped his son, Mike Jr., and his son's wife, Mary, open The Spaghetti Factory on Highway 57 in Mequon. Mike died at age 84 on August 31, 2000. (Photos courtesy of Mike Mille, Jr.)

51

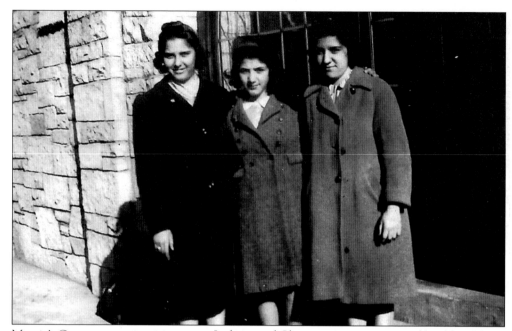

Mamie's Grotto, a tavern-restaurant at Jackson and Chicago streets, was owned by the Gigliotti family. It was popular with neighbors in the Third Ward, such as, from left to right, friends Margaret Mastrogiovanni, Mary Zizzo, and Mary Crivello. (Photo courtesy of Rose Mastrogiovanni.)

In 1936, Betty Puccio was a perky 1-year-old toddler, perfectly turned out in a light blue dress and white dress shoes and socks. Puccio grew up to be a major force in the Italian community, as a president of the Italian Community Center, as well as a businesswoman. (Photo courtesy of Betty Puccio.)

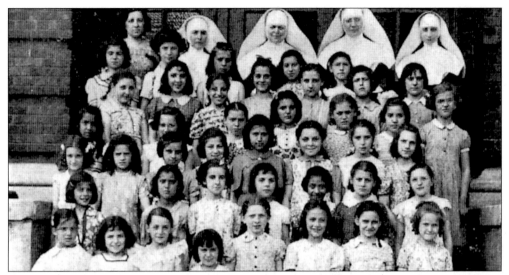

Many of the girls at Pompeii Church joined the St. Agnes Society. In 1939, some children lined up for a portrait. Pictured from left to right are: (front row) Rose Mastrogiovanni, Rose Mary Iannelli, Helen Civitarro, Anna Marie Carini, Norma Frinzi, Angeline Castiglione, Polly Zino, and Marie Cannizzaro; (second row) Anna Tarantino, Nancy Mastrogiovanni, Rose Crivello, Bessie Carini, A. Najera, Rose Gumina, and Mary Bellanti; (third row) Mary Cefalu, Rose Saggio, Rose Dragotta, Ann Maniscalco, Congetta Gallo, Rose Taormina, and unidentified; (fourth row) unidentified, Josie Accetta, Lucretia Sanfilippo, unidentified, Concetta Lococo, Rose Taormina, and Rose Gallo; (fifth row) Mary Alioto, Concetta Sorce, Alice Amoroso, Rose Sparacino, Sylvia Sciortino, and Theresa Dragotta; (sixth row) Margaret Carini, Grace Magestro, Mary Germaine, Connie Corrao, and Bessie Catalano; (seventh row) Agatha Busalacchi, Sister Diomira, Sister Letizia, Sister Irene, and Sister Frances. (Photo courtesy of Rose Mastrogiovanni.)

Mary Jane Lembo dropped by the convent near the Blessed Virgin of Pompeii Church sometime in the 1940s to say hello to her friend, Sister Frances Romolo. (Photo courtesy of Rose Mastrogiovanni.)

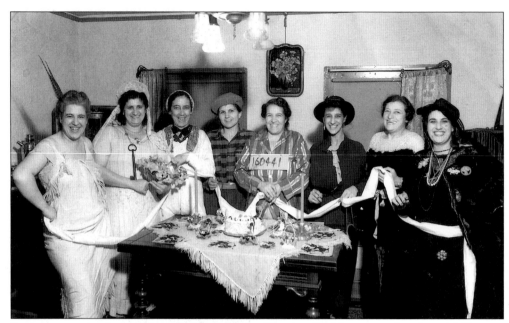

Everyone was having another wild time as the "Sewing Club" got together for a Halloween party on October 31, 1941. The ladies never sewed an actual stitch at these get-togethers, but held costume extravaganzas for each other's birthdays and played cards. First-generation Italian Milwaukeeans, they held jobs and took care of their families. Pictured from left to right are Jennie Puccio, Carms Muroni, Angie Palmisano, J. Sansone, unidentified, Lucille Romano Harmueller, Anna DiSalvo, and Angela Romano Pier. (Photo courtesy of Betty Puccio.)

Dressed as angels, four friends at Pompeii church were ready to tend to their flock of other youngsters making their First Holy Communion in the 1950s. Helping keep the little kids in line were, from left to right: Antoinette Gumina Mages, Christine Palmisano Mesenbrink, Mary Grace Zizzo Cicirello, and Mary Jane Lembo Banta. (Photo courtesy of Three Holy Women Parish.)

Sauntering down the street, brothers-in-law Joe Mastrogiovanni (left) and Sam LaBarbera went out on the town. Joe had just married Sam's sister, Francis, on May 17, 1946. (Photo courtesy of Rose Mastrogiovanni.)

Triscari's bar, at the corner of Van Buren and Brady streets on the East Side, was a hot spot in 1950. Gathering for a round of drinks were Peter Vella, Pat Lococo, Rose Vella, and Tom Lococo. (Photo courtesy of the Vella family.)

A well-coifed and smiling Angela Romano Pier was all ready for a wedding, decked out in her smart hat, brooch and suit outside St. Rita's church. Angela had an Italian gift shop on Van Buren, between Pleasant and Ogden streets. She also catered for private parties. (Photo courtesy of Betty Puccio.)

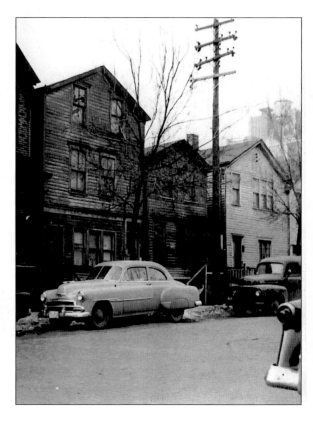

Small homes were crowded shoulder-to-shoulder on the south side of Detroit Street between Jackson and Jefferson streets in 1955. This contributed to a close-knit feel for the Italian neighborhood, one that lasted until urban renewal and freeway construction tore the heart out of the community in the 1960s. (Photo courtesy of Mario A. Carini, Italian Community Center.)

Italian families enjoyed getting together for a relaxing time in the early 1950s. In the upper photo, the ladies had a chance to converse. Pictured from left to right are: Angela Mastrogiovanni, Antonia Zizzo, and Theresa Catalano. In the lower photo (from left to right) Joe Zizzo, Dominic Zizzo, and Joe Mastrogiovanni chatted as they gathered around an early television set. (Photo courtesy of Rose Mastrogiovanni.)

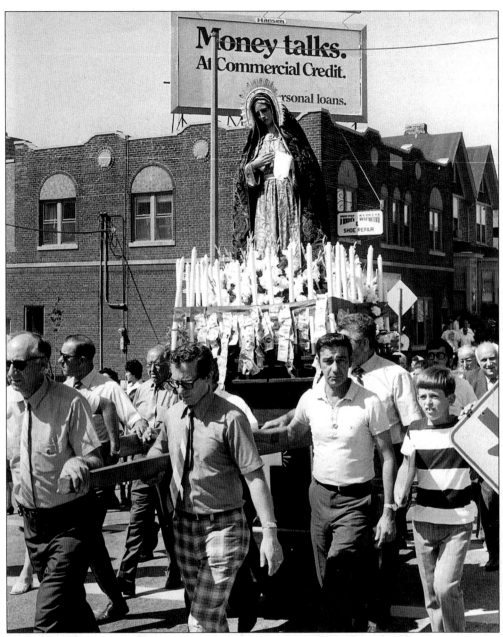

Escorting a statue of the Blessed Virgin was a serious affair for the men involved in a religious procession celebrating the Feast of the Ascension. The group made its way from the Blessed Virgin of Pompeii Church through the Old Third Ward. Tom Busalacchi (wearing a tie, front) was joined by Frank D'Amato. In the rear (seen behind the traffic sign, is Charlie Ingrilli, with Salvatore Patti on his right.) (Photo courtesy of Three Holy Women Parish.)

In this 1959 photo, Mary Louise Mussoline was only five years old, growing up in Hazelton, Pennsylvania. She and her husband, Dr. Jim Cope, moved to Milwaukee in 1981 where she became a fund-raising consultant working with the National Coalition Against Domestic Violence, and then for other nonprofits, including The Wisconsin AIDS Fund of the Greater Milwaukee Foundation, the YWCA, and Highland Community School. In 2002, she became vice-president for Institutional Advancement for the Milwaukee Institute of Art & Design in the Old Third Ward. A regular visitor to Italy, Mussoline is a founder of *Nuova Italia* (New Italy), a group of Milwaukee friends of Italian descent and those who love things Italian who meet socially for dinner, cultural events, and sparkling conversation. Mussoline's parents were from Reggio Calabria and Paterno, near Naples. Her maternal grandmother Mary Vito Beltrami came to the States at the age of five, sent on the boat with her name pinned on her dress and a woman who made sure that she got to her sister in Philadelphia. Her grandfather Salvatore Beltrami worked in New York City, constructing the subway system. Beltrami and her paternal grandfather, Rosario Mussolino, eventually worked in the coal mines in northeastern Pennsylvania. (Photo courtesy of Mary Louise Mussoline.)

The world of science opened eyes in St. Joan Antida High School for seniors in the class of 1960. Pictured from left to right, Rosalie Sanfelippo, Diane Nienhow, and Georgia Newth discover how radiological instruments work in a test to be used in case of a nuclear fallout. (Photo courtesy of St. Joan Antida High School.)

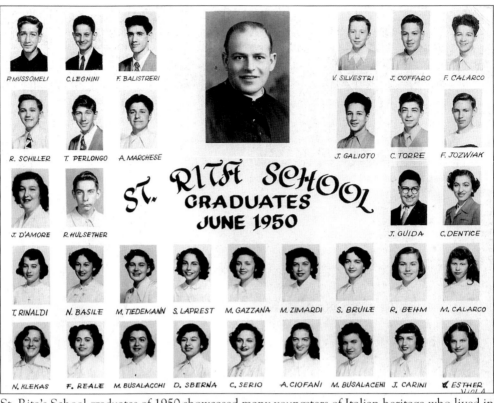

St. Rita's School graduates of 1950 showcased many youngsters of Italian heritage who lived in the neighborhood around Brady and Cass streets on Milwaukee's East Side. Father Primo Beltrame was featured amidst his "flock." (Photo courtesy of Three Holy Women Parish.)

Members of the Catholic Youth Organization of St. Rita's Church were all dressed up for a day's outing in 1961. Among those present were future Milwaukee Alderman Tom Nardelli (back row, far left). Others were Nunzio Maniaci (fourth from left), James Colla (sixth from left), and Father Tom Carlessimo. Among the women ,in the second row, from left to right, were: JoAnn Lemancyk, Phyllis Salza, Joanne Re, Teresa Mirenda, and Nancy Torcivi. In the first row, Nina Vella is in the middle and Angela Reale is second from the right. The others are unidentified. (Photo courtesy of Three Holy Women Parish.)

60

Carlo Tarantino, longtime "Mayor of Brady Street," and his son-in-law Dominic SanFelippo paused for a break in a friendly poker game during a family function in 1970. Carlo was born on May 17, 1887, in Mondello, Sicily. His parents sailed to the States on June 10, 1902, but were sent back to Sicily because his father, Antonio, was nearly blind. All but one of Carlo's sisters remained in Sicily with his parents, but the brothers and one sister came over to the United States over the years. When Carlo arrived in Milwaukee, he was sponsored by Joe Alioto who got him a construction job. Carlo then regularly sent money back to Sicily for medical treatments for his father. At first, he stayed with several other young Sicilian workmen, including Tomasso Cefalu, Andrew Machi, and John and Joe Alioto. In 1911, Carlo married Anna Gagliano and they had four children: Anthony (Duffy), Steve, Carlo, and Congetta. When Anna died in 1927 and he remarried, to Anna Miracola, in 1927. He then had five more children: Nick, Anna Rose, Rose, Lawrence, and Marie. Dominic, who worked for Milwaukee's Department of Sanitation, married Anna Rose in 1954 and died in 1986. At 95, Carlo came to live with Anna Rose and her children, Joe, Carla, Marie, and John. Carlo lived to be 99 years old. (Photo courtesy of Anna Tarantino SanFelippo.)

Selling bread at St. Rita's Church during a festival celebrating St. Joseph are, from left to right, Rose (Susie) Colla, Rose Agnello, and Antonina (Nina) Colla. At $1 a loaf, sales were brisk. (Photo courtesy of Three Holy Women Parish.)

Many businesses participated in Milwaukee's annual Columbus Day Festivities over the years. In 1969, Sally Papia, owner of Sally's Steak House, sponsored Kathleen Mirenda in a Miss Columbus Pageant. Kathleen won first runner-up. (Photo courtesy of Betty Puccio.)

Dr. Edward Leone, a past ICC president, earned a doctor of dental science degree from Marquette University in 1947, and a master's degree in education from MU in 1962. He was an adjunct professor at the Marquette Dental School for many years, published numerous articles in professional magazines, and was a president of the Wisconsin Dental Association. For his work, he received a distinguished alumni award and an excellence in teaching honor from the university. Always active in Italian affairs, Leone was president of the Milwaukee chapter of UNICO, and a district governor of the national organization. Serving in the Army in World War II and Korea, Leone earned 11 medals and attained a captaincy. (Photo courtesy of the Marquette University Archives.)

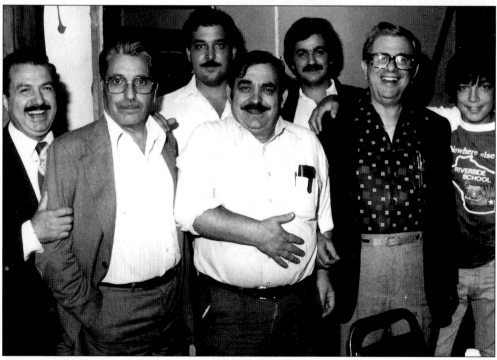

There were always smiles for the camera when this group of good friends gathered. Pictured from left to right in, 1980, are Lello Padrone, Dr. Liberio Farinella, Larrio Fazzari, Tony Fazzari, Tom Lo Duca, and 13-year-old Carmelo Fazzari. (Photo courtesy of the Fazzari family.)

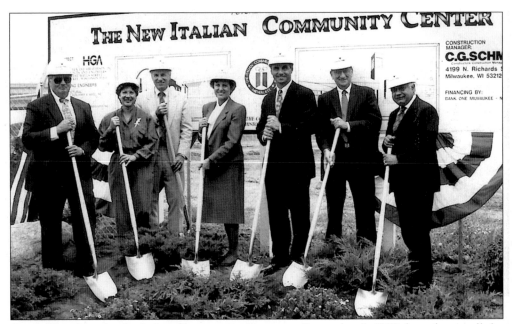

Ground-breaking for the Italian Community Center on September 7, 1989, brought out all the local Italian dignitaries. Pictured from left to right are: attorney John Fiorenza, head of the fundraising committee; Betty Puccio, ICC president-elect; project construction manager Richard Schmidt, president of C.G Schmidt, Inc.; Joan Gross, who served on the fund-raising planing task force; Sal Bando, president of Bando-McGlocklin Capital Corp., chairman of the solicitation campaign; Joseph Panella, president of the ICC; and Edward Leone, second vice-president of the ICC. (Photo courtesy of Betty Puccio.)

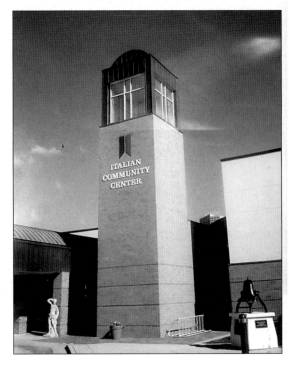

The Italian Community Center brings together all the memories of the old Third Ward and other Italian neighborhoods in Milwaukee. The facility contains restaurants, meeting rooms, bocce courts, and an outdoor plaza. The ICC has had many colorful members over the years, such as Louis A. Aveni, known as "Papa Luigi." Aveni was an honorary member of Gran Maresciallo of the Sicilian Band of Chicago, and often hammed it up for audiences at Festa Italiana. For years, he was the ICC's sergeant-at-arms. (Photo by author.)

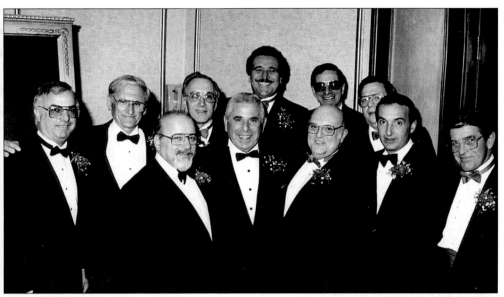

The Pompeii Men's Club gathered in 1986 at the Pfister Hotel's Grand Ballroom to honor Joe Glorioso (center) as its "Man of the Year." Glorioso was one of the original members of the Italian Community Center board of directors in 1978, and was re-elected for four consecutive terms. In 1981, he and his wife, Mary, were the King and Queen of Carnevale. Surrounding the guest-of-honor were, from left to right, Sam Purpero, Sam Balistreri, Tony Cusatis, Barny Maglio, Sal Mussomeli, Tom Consolazione, Eddie Glorioso, and Jimmy Rosso. (Photo by Dr. Edward Leone, courtesy of *The Italian Times* and Joe Glorioso.)

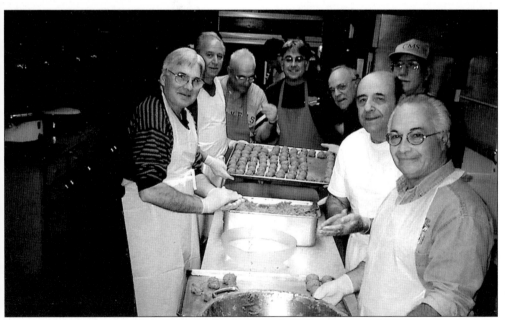

Members of the Pompeii's Men's Club prepared meatballs for the annual fall festival at St. Joan Antida High School, a tradition since 1955. The dinner celebrates the neighborhood's strong Italian roots and is a major fund-raiser for the school, bringing in $10,000 annually. (Photo courtesy of St. Joan Antida High School.)

Jennie Romano Puccio was the first woman president of the Italian American Federation of Milwaukee County, and was active in numerous other civic and social organizations. Born June 27, 1908, in Milwaukee, her parents were Benedetta Novara Romano and Pasquale Romano, both of whom came to Milwaukee in the late 1890s from Mistretta, Sicily. In Milwaukee, Pasquale became a lineman for the electric company. Jennie's husband, Joseph Puccio, was 24 years old when the couple eloped to Waukegan, Illinois, to be married when she was 14. Joseph used to pass her home on Pleasant Street every day on his way to work at a nearby leather factory, and "I fell in love with his hair," she joked years later. (Ironically, he became bald a mere ten years after their wedding.) The two remarried at Pompeii church, reconciling any potential family rift. The Puccio's first baby, Paul, died at nine months. The couple went on to have three more children: Pauline, Theresa (Tootsie), and Betty. Jennie Puccio died on August 14, 1995. (Photo courtesy of Betty Puccio.)

# Four

# A TRADITION OF
# PRAYER AND EDUCATION

In 1898, a converted tavern located on East Clybourn Street between Van Buren and Jackson streets was Milwaukee's first chapel to specifically serve Italian emigrants. It was called the Mission of the Most Precious Blood, served by Father Rosario Nasca, a native of Monte Maggiore, Sicily. He came from Chicago in 1899 to become the first resident pastor.

On June 25, 1899, Maria Caterina Lucia Palozzatio was the first baby to be baptized at the mission. On July 6 of the same year, Cologero Congo and Maria Comello were the first couple to be married there. In 1903, Reverand Dominic Leone began his pastorate, and began working to build a permanent church for his flock. Vincent Catalano, Mercurio D'Amore, Frank Spicuzza, Joseph Puccinelli, and Nicola Romano made up a building committee, helping purchase property on North Jackson Street for the structure. In 1904, the Blessed Virgin of Pompeii Church was completed.

Processions were the visible manifestations of the community's religiosity, harkening back to old Italy. Religious societies marched behind their colorful banners to celebrate the various feasts. Until the church was demolished in 1967, brass bands, featuring clarinets, tubas, and trombones, strode out behind altar boys who carried candles and the American flag as they proceeded from Pompeii church through the Third Ward. The demolition occurred despite the fact that the structure had been designated that same year as Milwaukee's first official landmark, with a luncheon being held at the Milwaukee Athletic Club, attended by many religious, business, and cultural leaders.

From Pompeii, sixteen women joined various religious orders: Sisters Mary Vincent Dragotta (SDC), M. Giovanna Antida Gigante (SDC), M. Agostina Balistreri (SDC), M. Paola Maiorana (SDC), Michael Vitucci (SDC), M. Concetta Germano (SDC), M. Josephine Dragotta (SDC), M. Frances Theresa Balistreri (SDC), M. Cecelia Tagliavia (SDC), M. Berchmans Dragotta (SDC), M. Agnes Dragotta (SDC), M. Giovanna Bellanti (SDC), M. Madonna Balistreri (OSF), M. Angelo Mussomeli (OSF), M. Matteo Cannizzaro (ND), and M. George Gentile (ND).

In 1926, Father Anthony Bainotti opened the St. Rita's mission on North Cass Street in the old First Ward to accommodate the expanding Italian community on the East Side, particularly in the Brady Street area. Seven years later, the Sisters of Charity of St. Joan Antida, primarily an Italian order, came to teach. In 1936, construction began on a permanent church and school, under the leadership of Father Ugo Cavicchi. Work was completed in 1939.

In 1945, the first full class graduated, with Monsignor Edmund J. Gebel, superintendent of the archdiocese's Catholic schools, handing out diplomas to the 22 boys and 23 girls. From that class came two vocations: Father Carl Alberte, who became pastor of St. Mary's Church, Pewaukee; and Sister Mary Cecilia Tagliavia, a Sister of Charity of St. Joan Antida, who eventually became general councilor of her order and lived in the motherhouse in Rome.

In the 1970s, an influx of new Italian émigrés to Milwaukee briefly revitalized the parish. However, the church school was closed in 1987 because of falling enrollment. Over the years, 43 classes were graduated, for a total of 1,492 pupils. The sad decision to close the institution was made by two alums: Sister Marie Louise (Rose) Balistrieri ('56) and Father Joseph Collova ('62).

In the 1990s, more changes took place in the Milwaukee archdiocese due to a shortage of priests. By 1995, parish collaborations were necessary, with one priest serving St. Rita and nearby Holy Rosary. In the early 2000s, St. Rita, St. Hedwig, and St. Rose congregations were united into the Three Holy Women Parish, with its parish house and offices at Humboldt and Brady streets.

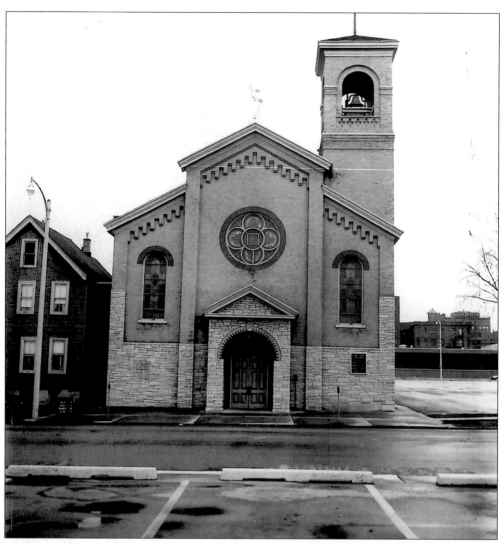

The Blessed Virgin of Pompeii Church was the centerpiece of the Italian community in the old Third Ward. Built in 1904 to serve 120 neighborhood families, it was eventually razed to make way for a freeway in 1967. On January 17, 1905, Salvatore Dentice and Lucrezia Busalacchi were the first to be married there. The parish's Golden Jubilee was held in 1954, with Archbishop Albert G. Meyer celebrating mass. A religious procession followed through the Third Ward, with 700 persons then attending a banquet at the Pfister Hotel. In 1964, the 60th anniversary of the parish was celebrated in the church hall, with the program's main speaker, Father Salvatore Tagliavia saying "it was the most wonderful evening in the history of the church." (Photo courtesy of Three Holy Women Parish.)

The baptismal font at the Blessed Virgin of Pompeii Church marked where most Italian youngsters were introduced into their Catholic faith. Salvatore Purpero was the first youngster to be baptized at the church, on January 1, 1905, and Jeffrey Joseph Colla was the last, on February 12, 1967. The ornate font, with a depiction of Christ being anointed by John the Baptist, was the heart of the church. Here, hundreds of babies, as well as adult converts, received the blessing of the Church and the community. A side altar depicted St. Joseph holding the baby Jesus, with side statues of other saints looking on. (Photo courtesy of Three Holy Women Parish.)

A memorial beneath the twisting ramps of the I-794 freeway south of downtown Milwaukee is the only indication that a thriving Italian community once lived in the area. The plaque marks the razing of the Blessed Virgin of Pompeii Church. (Photo by author.)

"Gabriel" is a bronze angel statue cast in Florence by Gaetano Trentanove in 1904. Trentanove did some sculptures for the Chicago World's Fair in 1893, and was lured to Milwaukee by the promise of more work, commuting between his new home and Italy. When plans for the Blessed Virgin of Pompeii Church were finalized, Trentanove decided to donate the angel. When it was placed on the roof, the parish bell (Laura) was rung for thirty minutes in celebration. After the church was razed in 1969, Gabriel came into the possession of Joseph Saggio, president of Saggio Nursing Home. In 1969, the statue was donated to the Pompeii Men's Club which then gave it to St. Rita's Church. It was restored and rededicated in 1994. (Photo courtesy of Three Holy Women Parish.)

An 800-pound bell, nicknamed "Laura" (meaning "Glory"), that once hung in the steeple of the Blessed Virgin of Pompeii Church, is now prominently displayed near the main entrance of the Italian Community Center. For 62 years, Laura's pealing called Third Ward worshippers to liturgies, weddings, funerals, and other services. Money for the bell, which was cast in Cincinnati, was raised by Father Dominic Leone, Pompeii's first full-time pastor, along with others in the community. The bell was donated to the center by the Di Frances family, which had acquired it in 1967, when the church was demolished. At the time, Joseph Di Frances Sr., and his son Joseph Jr., owned and operated Northwest Wrecking Company which leveled the structure to make way for a freeway ramp. The bell was then loaned to St. Elizabeth's Catholic Church, but eventually replaced by a bell from another church that had been closed by the Milwaukee Archdiocese. Past ICC president Phillip Purpero hired a crane and two of his employees from C.W. Purpero Inc. to salvage the bell. (Photo by author.)

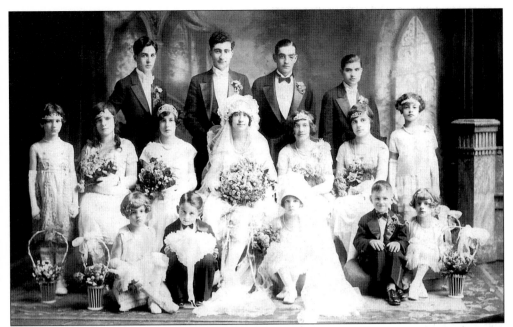

Getting married was a formal affair for Phillip and Mary Costantino. The youngsters are, from left to right: (front row) Betty Gagliano, Frank Balistrieri, Rose Balistrieri, Frank S. Balistrieri, and May Gagliano; (second row) Rose Balistrieri, unidentified woman, Rose Puccio, Mary Costantino, Carmela Paciuno, unidentified woman, and Pauline Comello; (back row) Fred Puccio, Phillip Costantino, John Puccio, and an unidentified man. (Photo courtesy of Frank Balistrieri.)

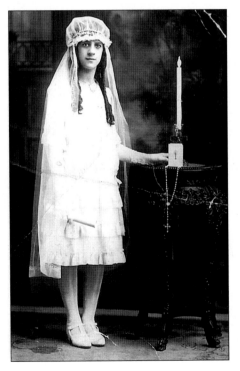

Lucy Romano was a lovely young first communicant in her white dress and fancy shoes. A burning candle and rosary beads were important parts of the composition. (Photo courtesy of Betty Puccio.)

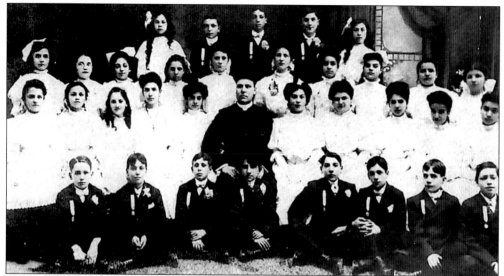

The communion and confirmation class of April 21, 1907, sat proudly with Father Dominic Leone of Blessed Virgin of Pompeii parish. Everyone was dressed for the occasion, with dark suits for the boys and white dresses for the girls. (Photo courtesy of Three Holy Women Parish.)

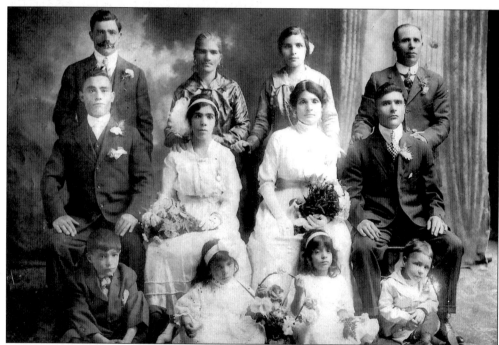

A double wedding was probably doubly blessed in this portrait of two serious couples and their wedding parties in 1918 at the height of World War I. Pictured from left to right are: (back row) Afio Librizzi, Carmella Randazzo Librizzi, Dorothy Librizzi Aveni, and Dominic Aveni; (seated) Joe Ricca, Mary Librizzi Ricca, Mayme Pizzino, and Joe Pizzino. The youngsters in front are Tom Librizzi (who would be killed in World War II), Rose Librizzi Kozabucki, Mary Pizzino, and Lou Aveni. They were probably worried because another Librizzi, Lawrence, was fighting in the European trenches. (Photo courtesy of Terry Aveni .)

Father Carlo Cellotto served as pastor of the Blessed Virgin of Pompeii Church in 1925. In that year, Archbishop Sebastian Messmer placed the facility's administration under the Pious Society of St. Charles, founded in 1880 by Bishop J.B. Scalabrini of Piacenza, Italy. The order fanned out around the world, caring for Italian immigrants wherever they needed spiritual assistance. Following Cellotto was Father Antonio Bainotti, who remained until 1935. He established the Sodality and the St. Vincent de Paul Conference. (Photo courtesy of Three Holy Women Parish.)

A longtime friend of the Milwaukee Italian community, Father Gregory Zanoni, CS, was born in Cloz, Trento, Italy, on June 29, 1908, one of 14 children. At age 11, he entered the Cristoforo Colombo Institute in Piacenza, where the Scalabrinian order of priests has its Mother House. He studied there for 12 years and was ordained to the priesthood on March 21, 1931. Father Gregory then was sent to the United States and assigned to the Province of St. John the Baptist, which is headquartered in Chicago. In 1947, he came to Milwaukee, becoming pastor at Blessed Virgin of Pompeii and then at St. Rita's Church for a number of years. Father Gregory then became a missionary in Brazil and eventually preached parish retreats in Canada and served Italian congregations in England. He died September 28, 1995, in Arco, Trento. (Photo by Fabio Galas, courtesy of Three Holy Women Parish.)

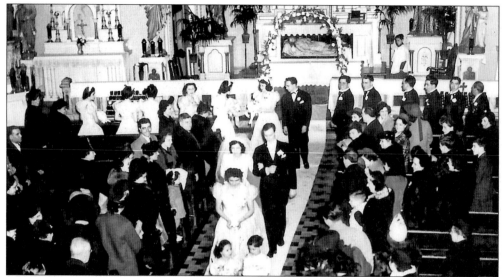

The wedding of Sam and Connie Balistreri was the social event of 1942. The radiant bride and handsome groom walked down the aisle to the smiles and support of the congregation after the ceremony in the Blessed Virgin of Pompeii Church. Mario A. Carini was the ringbearer and JoAnn Piano was the flower girl. Many such ceremonies meant wonderful memories over the years. The last wedding at the church before it was demolished in 1967 was that of John L. Bottoni and Jean Michalovitz on November 26, 1966. (Photo courtesy of Mario A. Carini, Italian Community Center.)

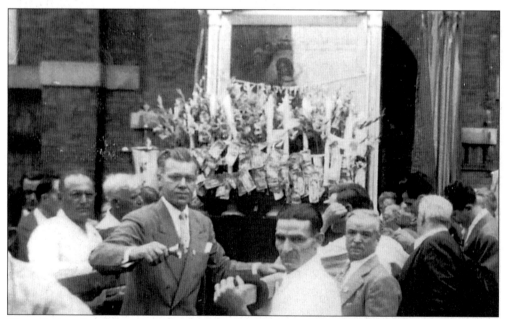

The carrying of statues bedecked with money is an ancient Sicilian tradition for marking special feast days and church occasions. Here, in July of 1948, a group of men brought out a float from the front door of the Blessed Virgin of Pompeii Church, as other worshippers crowded around. The man with the bell was Ted Crivello. Frank Sanfelippo is the worshipper wearing the suit, facing the camera. (Photo courtesy of Mario A. Carini, Italian Community Center.)

The rectory for St. Rita's Church was located at 1617 N. Cass Street for many years. This photo was taken in 1939. However, as a mission "outpost" of the Blessed Virgin of Pompeii, a house had been purchased at 1329 N. Cass Street in 1918 by the Carmelite Sisters, to use as a church and school. In the spring of 1938, St. Rita's received permission to build a permanent church with a classrooms on the second floor. (Photo courtesy of Three Holy Women Parish.)

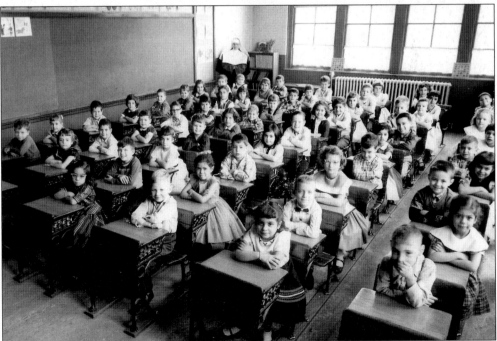

Under the keen eye of the sister in the background, these pupils at the old St. Rita's School were ready and eager to learn. (Photo courtesy of Three Holy Women Parish.)

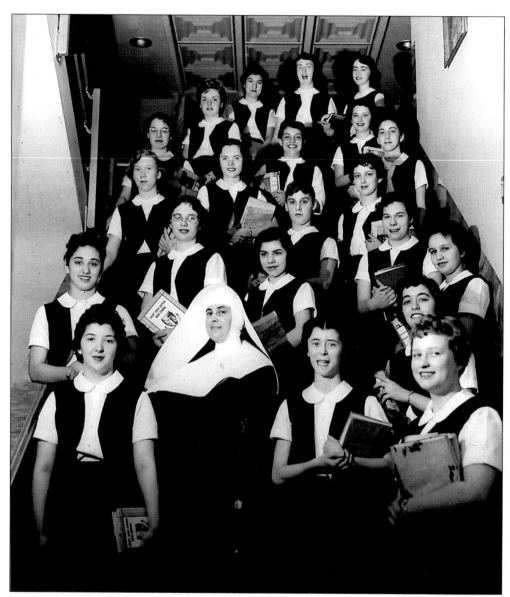

Sister Letizia Comillei stood in front of the St. Joan Antida Joanettes' classes of 1958 and 1959. Graduates of 1959 of Italian heritage were Anna Marie and Rose Balistreri, Mary Balistrieri, Frances Balzano, Domenica Bartolme, Marie Cannariato, Janice Cira, Carol Ghirardini, Anita Gregorio, Ann Marie Marola, Marie Mirenda, Therese Olla, Carmela Re, Rosemary Sanfelippo, and Barbara Vitrano. St. Joan Antida High School has long been a fixture on Milwaukee's East Side, opening its doors to 47 young "freshwomen" in 1954. They were taught by both Sisters of Charity of St. Joan Antida and by laypeople, many of Italian heritages During its history, the school has had five principals: Sister Alfreda Scurti (1954-1964), Sister Letizia Camilleri (1964-1967), Sister Joan Antida Gigante (1967-1973), Sister Mary Rarcisia Tonna (1973-1981), and Sister Monica Fumo (1981-2000). Lynn Ann Resseman served as principal from 2000-2002, with alumnus Susan Czarnecki Henzig ('64) from 2002-2004. Susan Smith was appointed in February, 2004, as the school's first-ever lay president. (Photo courtesy of St. Joan Antida High School.)

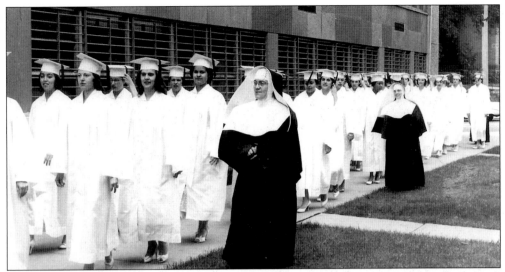

The proud members of St. Joan Antida's first graduating class proudly filed past the school, under the watchful eyes of principal Sister Alfreda Scurti (left) and Sister Letizia Camilleri. (Photo courtesy of St. Joan Antida High School.)

Born November 16, 1931, Father James Groppi was one of twelve children of Italian immigrants Mr. and Mrs. Giocondo Groppi, who operated a grocery store in Bay View. After attending St. Francis Seminary, he was ordained in 1959 and eventually assigned to St. Boniface parish in Milwaukee's Inner City. He participated in civil rights marches in Washington, D.C., and in the South, and began advocating local open housing. Leaving the Catholic priesthood in 1976, he married, and began studies for the Episcopal priesthood. However, his commitment to Catholicism led him to discontinue those studies and he became a Milwaukee County Transit Company bus driver and a union leader. Groppi died of cancer on November 4, 1985. The 16th Street Viaduct over the Menomonee Valley, where many of the marches took place, was named in Groppi's honor. Groppi was arrested several times for his involvement in open housing marches in Milwaukee during the late 1960s. This police mug shot is from around that time. He led 200 consecutive marches, often accompanied by his bodyguards, a group of young black men from the NAACP Youth Council Commandos. (Photo courtesy of the Milwaukee Police Department.)

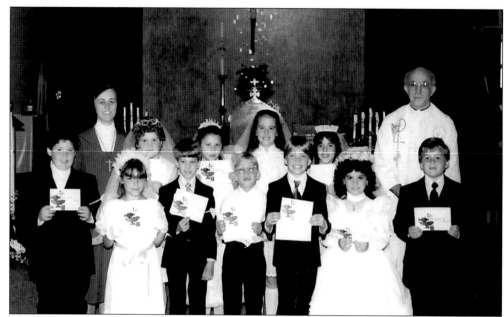

The First Holy Communion class of 1985 at St. Rita's Church included Shannon Bash, Francesa Carini, Jennifer Connors, Donald Crivello, Stacy Czarnecki, Shannon Drezek, Kristian Plumeri, Jeffery Prichard, John Schramm, Michele Sgroi, and Robert Yenter. Sister Maria Louis Balistrieri of the Sisters of Charity of St. Joan Antida (SCSJA) and Father Albert Carradin (CS) proudly stood beside the youngsters. (Photo courtesy of Three Holy Women Parish.)

Archbishop Gabriel Montalvo, papal nuncio to the United States, watches as newly installed Archbishop Timothy M. Dolan kisses the crosier given to him by Montalvo. The ceremoney was held on August 28, 2002, in St. John's Cathedral. (Photo courtesy of Sam Lucero, *The Catholic Herald*.)

# Five

# A KEEN EYE FOR BUSINESS

Milwaukee's eager-to-succeed Italian community quickly had a hand in a variety of businesses, ranging from grocery stores and taverns to wholesale fruit distribution.

Kellogg's Corn Flakes were big sellers in Salvatore Catalano's grocery store in 1943. The Catalono family was one of the first to settle in the Third Ward. La Piano's Drugstore, 301 N. Jackson Street, was adjacent to Pompeii church, and had a well-apppointed soda fountain as early as 1929. Pasquale and Jennie Migliaccio featured stacks of cans of tomato sauce, tins of olive oil, and a glassed-in candy display that was the envy of neighborhood youngsters. Joe Frinzi and his son Gino operated a meat market on Detroit Street for many years. Customers in the 1930s always got a kick out of the mounted deer head hanging behind the counter amid the sausages and other meats.

In 1955, future circuit court judge/ICC leader William A. Jennaro worked in his father's fruit market at 14th and Wells streets, now a parking lot for Marquette University.

Operating a tavern was natural in a city where beer brewing was a major industry. Tony Bellanti made sure that everyone understood that in his place, credit was out of the question. In 1909, a sign behind his ornate bar proclaimed that "in God" he trusted, "but all others pay cash." Frank Colla was a well-known pub-keeper in the 1930s, his tavern located on the northeast corner of Menomonee and Jefferson.

In the 1950s, Mamie's Grotto was a noted tap and lunch spot on the northwest corner of Jackson and Chicago streets in the Third Ward. Many of the Commission Row warehousemen and vegetable dealers used to grab a bite there. Today, the site is near the location of the sprawling Italian Community Center. A happy crowd always gathered in the 1930s and 1940s at Eugene Vaccaro's Tumble Inn located at Lyon and Van Buren streets.

But times change. Teddy's Disco, located at 1434 N. Farewell Avenue and managed by Mark Pucci, is no more. And the old Stork Club in Riverwest has morphed into the Nessun Dorma, a modernistic bar owned by Joe Gilsdorf and Dean Cannestra. In the early 2000s, the two men met at Palermo Villa, an East Side Italian restaurant owned by Cannestra's sister, Kathleen Cannestra Mirenda. Gilsdorf dropped into the Palermo one evening as Puccini's opera Turandot was playing in the background. He and Cannestra began talking and wound up as partners. They named their new bar after an aria from the opera; the title means "no one sleeps," which is a proper title for a Milwaukee bar.

Italian Milwaukeean business owners always make the time to serve the broader community. Jimmy Spataro, president of American Moving & Storage and president of the Italian Community Center in 1985, was appointed to serve on the Private Industry Council of Milwaukee County in 1992. Harry Quadracci, owner of QuadGraphics Printing, was a noted Milwaukee philanthrophic leader. Sandy D'Amato is one of the country's most noted chefs, at the helm of his Sanford Restaurant and Coquette Cafe. Don't forget to add Balistreri, Barbiere, and Carini to the menu of Milwaukeean restauranteurs!

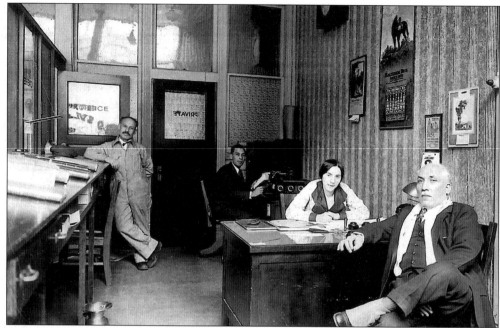

No Milwaukee office in the 1920 and 1930s was complete without a brass cuspidor on the floor, or a self-winding Western Union clock on the wall. Yet employees of the Migliaccio & Vallone fruit company also had a typewriter to make their job easier when preparing receipts and invoices. Leaning against the desk on the left was Tom Migliaccio, with his brother Pasquale in the dark suit, to his right. In the front of the photo is Pasquale's partner, Joe Vallone. The stenographer's name was Jenny. The firm, located on Commission Row in the Third Ward, started up in the early 1900s. It supplied fruits and vegetables to area grocery stories until 1949. Pasquale had come from the Palermo area of Sicily as a young man, living on Detroit Street. Once established in the Italian grocery business, he then opened Como's Restaurant at 27th Street and Wisconsin Avenue. (Photo courtesy of Mario A. Carini, Italian Community Center.)

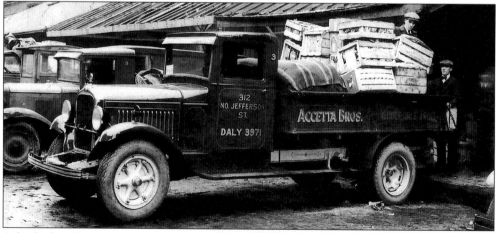

A load of produce was ready for delivery by the Accetta brothers, with Paul on the truck and Jack loading from the rear. This shot was taken on February 19, 1931, on Broadway along Commission Row. The men eventually founded the Village Fruit & Market on Silver Spring Drive. (Photo courtesy of Geraldine Accetta.)

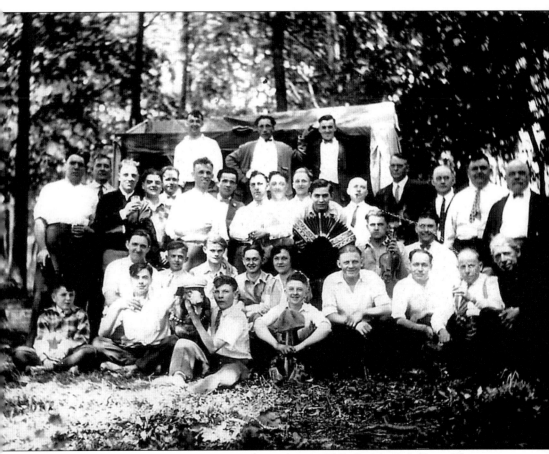

It wasn't all work at the T.H. Stemper Co., located at 1125 E. Potter, Bay View. There was always time for a company picnic with concertina music and food. Even the company mascot came along. At the far right is T.H. Stemper, a Milwaukee entrepreneur with a Luxembourg heritage who hired many Italian workmen over the long history of the company. The company was founded in 1894 but went bankrupt. It was purchased in 1911 by T.H. Stemper, a music teacher who continued to emphasize high quality in the making of altar rails, statues of saints, and other religious items. In 1913, Stemper bought Milwaukee Church Supply and moved that business to 1125 E. Potter Street, where the statuary factory was located. A blacksmith shop was on the second floor, where intricate ironwork was produced. In 1946, the companies merged under the Stemper name, and this entity remains one of the country's largest suppliers of church-related items. The firm, still in the original building, is now owned by Stemper's daughter-in-law, Jean, and operated by his grandsons, Dan, Peter, Joe, John, and Jim. Many Italian men had jobs at both firms, including: Frank Pescosta, who was in charge of clay modeling and wood carving; Alfred Marchetti, in casting; Anthony Piacentini, in finishing; Vincente Pescosta, in marble; Baptista Richetta, in altar rails; and Americo Rochetti, a mosaics specialist who spent 52 years with the company. (Photo courtesy of Jean Stemper.)

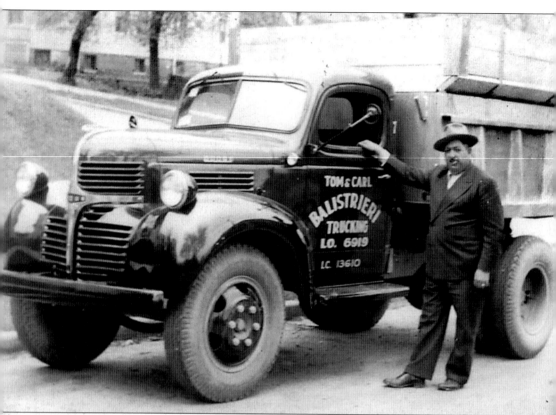

In the old days, when applying for a license plate, it was necessary to take a photo of the vehicle on which the plate would be placed. So, Tom Balistrieri proudly stood by his new dump truck in 1939, prior to heading downtown to purchase his plates. He hauled rubbish and cinders from hotels and restaurants. (Photo courtesy of Frank Balestrieri.)

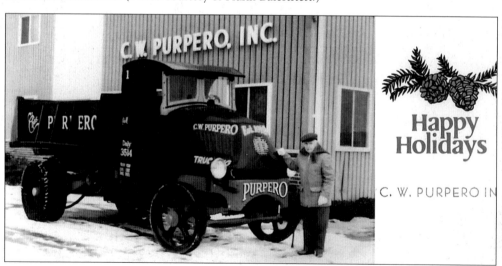

Snow on the ground reminds Milwaukeeans of a frosty winter when Charlie Purpero sent out his company's annual holiday greeting cards, showcasing an old dump truck near the firm's garage on Jefferson Street. (Photo courtesy of Joe Glorioso.)

Dominic Rossetto operated the Uniti Bar, 1124 N. Water Street, from the late 1940s until the 1960s. He was 18 years old when he came to the United States in 1914. The Uniti was torn down in the mid-1970s and the site is now the beer garden of the Brew City Barbecue restaurant. The Uniti was a well-known bluecollar bar, attracting the workers from nearby Blatz, Pabst, and Schlitz breweries. (Photo courtesy of the D'Amato family.)

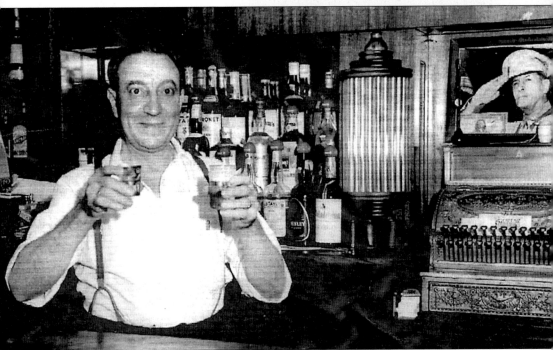

Alfred Sanfilippo was the happy bartender at the Brite Spot Cafe in the Third Ward, one of the more popular places for all the locals in the neighborhood. (Photo courtesy of Marino A. Carini, Italian Community Center.)

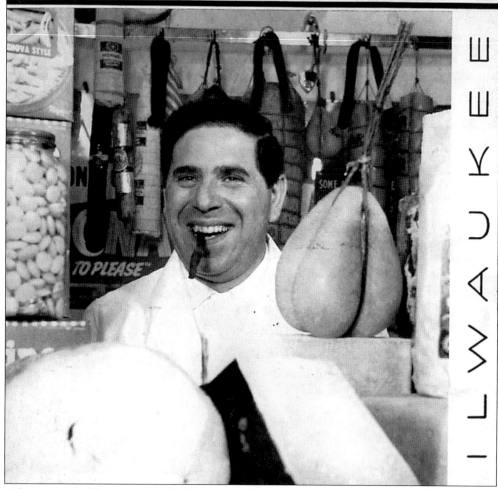

A beaming Joe Glorioso made the front page of the *Let's See* magazine in the autumn of 1958. Glorioso was honored as the 1992 Outstanding Italian Person of the Year, a community service award. Glorioso was born April 20, 1922, to Felice and Therese Glorioso, whose home was on Detroit Street in the old Third Ward. He was the first of seven children. Following high school graduation, he worked at Seemann's Fine Foods on Green Bay Avenue from 1940 to 1942, then served in the army in Europe during World War II. After his discharge, he and his brothers Eddie and Ted opened their retail grocery on Brady Street in 1946 and eventually expanded into wholesale distribution of Italian foods. Over the years, the three also owned Trio's Pizza and Glorioso's Italian Villa restaurants. Joe married Mary Frances Frinzi in 1950 and had two children, Felice Joseph and Rena Marie. Glorioso helped start Festa Italiana and the Italian Community Center, and was active in UNICO, the Holy Crucifix Society, and the Pompeii Men's Club. His wife Mary died in 2004. (Photo courtesy of Joe Glorioso.)

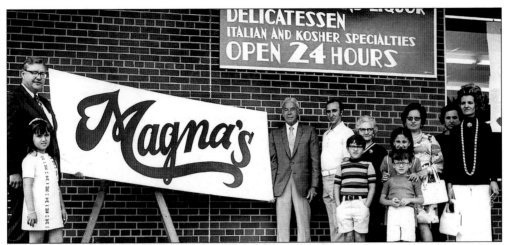

Everyone posed proudly at the grand opening of the 9,000 square-foot Magna's grocery store at the corner of Green Tree and Green Bay roads in Glendale in 1972. Pictured from left to right are: O.K. Johnson (of Western Bank), Maria Megna, Robert Cayze (Glendale mayor from 1971-1973), Joe Megna, Michael Megna, Maria Valenta, Anna Catania (with her children Maria Carmello and Giovanni who were visiting from Porticello, Sicily), Grazia Crivello, and Girolama (Mimma) Megna. The store remained with the Megnas for a year, after which Mimma opened an Italian gift shop at Oakland and Lake Bluff. She then went on to operate a catering business and restaurants in the Milwaukee area, including the popular Mimma's, at 1307 E. Brady Street, and Vucciria's, at 1323 E. Brady Street (Photo courtesy of Girolama (Mimma) Megna.)

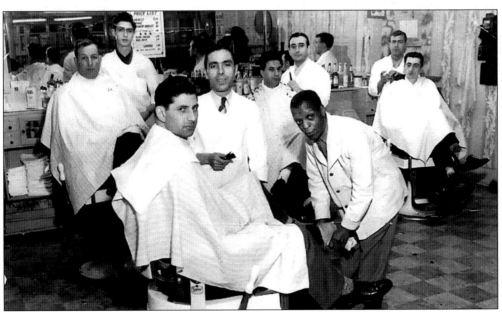

In 1949, the best place on the East Side for a haircut was the Ogden Barbershop, at 1132 E. Ogden Street. Frank Balzano, the shop's owner, is at the front chair, with Johnny Maio, about to get his shoes shined by the shop's resident polisher (unidentified). Showing off their tonsorial techniques in the back row of chairs are, from left to right: Peter LaBarbera, with Tony Sanfelippo; Nick D'Amato, with Sam Caruso; and Ralph Yob, about to cut the hair of Jimmy Zingale. (Photo by Joe Carini, courtesy of Peter LaBarbera.)

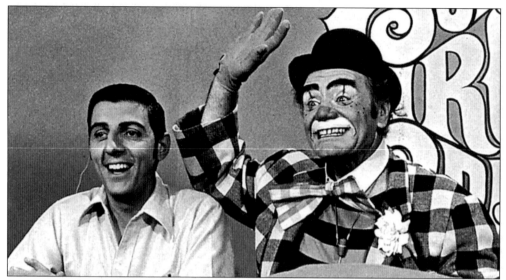

Communications specialist Robert Ruggieri is a former chairman of the *Italian Times* Newspaper Committee (formerly known as the editorial board), and remains a regular columnist for the newspaper. He graduated from the University of Wisconsin-Madison in 1957, and was an account executive with Barkin, Paulsen & Kimball Public Relations from 1968 to 1991, before launching his own company. Here, he is pictured with actor Ernest Borgnine, who is dressed as a clown for the Great Circus Parade. Ruggieri also headed Festa Italiana's public relations committee, was an ICC board member, and headed the ICC Columbus Day Quincentennial Committee. (Photo courtesy of Robert Ruggieri.)

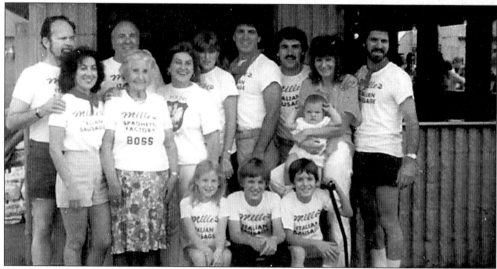

The Mille family gathered in front of its Italian sausage stand at the Wisconsin State Fair sometime in the 1970s. Pictured from left are: Walter Atkins; his wife, Antoinette Mille Atkins; Mike Mille Sr.; Grandma Antoinette Mille; Alice Mille; Therese Mille; Amatore (Matt) Mille; Mike Jr.; Mary, Mike Jr.'s wife (holding daughter Megan); and Mark Mille. In front are Mike and Mary's kids, Melissa and Mike III, who are on each side of Matt Jr. The now-far-flung family still gathers from around the country to work the State Fair each year. (Photos courtesy of Mike Mille, Jr.)

Peter LaBarbera has been cutting hair since he was 10 years old, learning in his home village of Santa Flavia, Sicily. He came to Milwaukee in 1946, living with his parents Joseph and Sally LaBarbera at 440 N. Van Buren Street, behind the Andrew Jackson School playground. When he was 18, he began professionally barbering. More than 50 years later, he's still on the job. In the chair is Joe Benvenuto, who has been coming to LaBarbera's shop since he was a kid. Benvenuto's grandfather, Vincent, and dad, Joe, were also trimmed at the shop, as is Joe Jr.'s son, Nick—LaBarbera's work spans four generations. A devoted Tosca fan, LaBarbera is known for playing operas in his shop at 1027 E. Brady Street. (Photo by author.)

Sicilian-born Ignacio Reina came to Milwaukee when he was 17, along with his parents Mr. and Mrs. Filippo Reina. Earlier, Filippo's brother Giorena and sister Gionni had already settled in the city. The family opened Vespa motor scooter and international auto sales outlets in West Allis in 1980, and in Brookfield in 1989. (Photo by author.)

Born in Milan in 1941, Alberto Colella became vice-president of sales for North American Cerutti Corporation. He came to Stateside in 1996, first to Pittsburgh where Cerutti had a large plant. Colella and his French-born wife, Frederica, moved to Milwaukee four years later, when his parent company purchased a platen die cutter supplier plant in New Berlin. The firm employs four Italian nationals and 120 Americans. Gruppo Cerutti, located in Casal Monferrato, between Milan and Turin, has production plants in Italy and Spain, as well as the United States. Before coming to the States, Alberto was in charge of all English- and German-speaking markets, excluding those in the United States, leading him to travel the world for 10 years. (Photo by author.)

Milwaukeean Mike Diliberti is a senior country officer at the World Bank in Washington, D.C. This photo shows him leading a discussion on budget planning and management for administrators of World Bank offices in Africa. The seminar took place in Accra, Ghana, in 2002. His current assignment is working in the Office of the Country Director for Ghana, Liberia, and Sierra Leone. Diliberti coordinates and facilitates the work of the World Bank country teams for Liberia and Sierra Leone and helps plan, implement, monitor, and evaluate World Bank activities in these two countries. He started at the World Bank in 1985, after receiving his bachelor's degree in education from UWM in 1974, a master's in International Affairs from Ohio University in 1981, and a second master's in geography from Ohio University in 1982. He also served in the Peace Corps from 1974 to 1978 in Sierra Leone. Mike and his family grew up across the street from his grandparents, Pietro and Grazia Diliberti, at 3427 W. Scott Street. The elder Dilibertis immigrated to Milwaukee in 1908 from Balistrate, Sicily. (Photo courtesy of Mike Diliberti.)

Fran Naczek-Maglio-O'Brien has plenty of ethnic links within her family, all of which are helpful because she co-owns Gerry O'Brien's International Meat Market and Fran's Italian Deli at 6732 W. Fairview Avenue. Her dad, Richard Naczek, married her mother, Concetta Maglio, in 1953, shortly after he returned from service in Korea. Fran's grandfather, Savario Maglio, and grandmother, Francesca

Olla Maglio, came from Sant' Stefanos, Sicily, to Milwaukee in the early 1900s. Savario began selling fruit around the city, using a horse-drawn cart to call on his customers. He also helped coordinate the colorful tradition of processions on church feast days. Gerry and Fran met at the 1986 Festa Italiana, where Gerry was volunteering during a vacation from his home in Manchester, England. On an earlier trip to the Canary Islands, he met Milwaukeean John Zizzo, who invited him to the city to visit. He did, and was smitten with Fran, who was working Uncle Barney Maglio's fruit stand and at the fest. The couple married in 1987 and they have two kids, Danny and Angie. When Gerry decided to settle in Milwaukee, Eddie Glorioso, who had just opened Glorioso's Prime Meats at 68th and Wells, hired him as a butcher. After two years, Eddie sold the store to the O'Briens. In 1991, they moved their operations to their current location, a building housing a grocery store since the 1920s. With a fully renovated facility in 2004, Gerry and Fran still serve up cuts of spiedini and braclioni, homemade Italian sausage and gallons of fresh sauce.... along with Irish soda bread, white and black puddings, and bangers and crisps. (Photo by author.)

Lovers of Italian food products can find almost anything they're wishing for at Aveni's speciality shop at 1664 N. Van Buren Street. Owner Terry Aveni had been an engineer for more than 20 years but burned out with that job. Seeking new adventures about eight years ago, he purchased the old John Busalacchi grocery store where he used to visit as a youngster. The business had

been a Van Buren Street fixture since 1952. Jim Aveni, Carl Alberti, and Guy Niver assist in the shop, while part-time cook Sharon Picciolo helps makes the store's spaghetti sauce and other food items. But Aveni is also a cook, who learned by watching his French mother at home. She had picked up her considerable kitchen skills from her father-in-law, Aveni's grandfather, Dominic, who came from Tripi, Sicily. Dominic became a cook on a Great Lakes freighter, but fell overboard one day and swore never to get on a boat again. (Photo by author.)

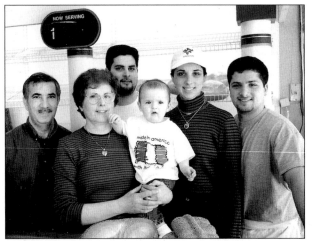

The Peter Sciortino Bakery, at 1101 E. Brady Street, is in good hands under the ownership of the Vella family. The East Side landmark, which opened in the 1940s, was purchased in 1997 by Maria Vella Sali (center with hat) and her two brothers, Giuseppe and Luigi (to her left and right). Helping out in the store are their parents, Maria and Salvatore Vella, and Giuseppe's son, little Salvatore. The elder Salvatore sailed to the United States in 1969 with his parents, Giuseppe and Maria of Porticello, Sicily. Salvatore's father worked in construction in Milwaukee, while he became a maintenance worker at the Falk Corporation. Salvatore returned to Sicily to marry Maria, and the couple then returned to Milwaukee in 1971, where their children were eventually born. Staying close to their work, the three younger Vellas and their spouses live in the apartments above the bakery. Giuseppe's wife is Rhiana Philipps, Luigi is married to Ann Metrusias, and Maria's husband, Paolo Sali, was born in Hartford, Wisconsin. His father, Riccardo Sali, came to Wisconsin from Cremonain the early 1950s to work as a cheesemaker in Hartford. (Photo by author.)

Chef Peter Carini stands with his daughter Lisa in the family restaurant, La Conco D'Oro, on Milwaukee's East Side. In 1966, Carini came to the city from Porticello, Sicily, with his father, Guiseppi, and mother, Francesca, along with his brothers and sisters: Rosario, Santo, Albert, Salvatore, Maria, and Antonia. The family sailed aboard the S.S. Anna Maria, departing Palermo for New York and a new life in the United States. Carini's grandfather, Santo Balistrieri, had come to Milwaukee in the 1930s to work as a fireman on the railroad. He returned to Sicily to marry his wife, Giovanna, and then returned to America. Peter Carini opened his fine dining establishment in 1996 at 3468 N. Oakland Avenue, after working in several other kitchens around Milwaukee. The extended Carini clan often helps at the restaurant. His brothers Sal, Albert, and Rosario are often weekend chefs, along with his son Greg. Lisa is a hostess and the youngest son, Peter Joseph, a waiter. Murals by Joel Koch and photos by Esther Shapiro brighten the restaurant's rooms, along with a large portrait of his parents, visible in this photo, which hangs on the back wall. (Photo by author.)

# Six

# HERE COMES THE LAW

Milwaukee's Italian community has always been ready and eager to share its multitudinous talents in the political and legal spheres. Among the many leaders in the history of the community is Michael M. Jendusa, who lived at 1335 S. Layton Boulevard, and represented the old 23rd aldermanic district. He was elected on June 22, 1945, in a special election following the death of incumbent Fred A. Scheibel. Jendusa served until April 17, 1956. Felix Lassa also represented the 8th district.

Another major Italian Milwaukee political leader, Anthony Maggiore—who died June 17, 2004, at 68—devoted his life to helping the poor as associate director of the Social Development Commission. His proudest achievement was starting a low-income energy assistance program. Maggiore was also an adjunct professor at the University of Wisconsin-Milwaukee School of Social Welfare, and research director for the Milwaukee Homicide Project, which tried to reduce inner city youth homicides. Also serving the Milwaukee public have been Milwaukee County court commissioners Anthony Machi and John J. Valenti. Among the county's Circuit Court judges have been Dominic S. Amato, John and Jean W. DiMotto, and Clare Fiorenza.

Italian Milwaukeeans still have an abiding love affair with their native country. In the spring of 2004, Italian citizens living outside their country had their first opportunity to cast ballots by mail in the election of members to the Comites. This committee is liaison between citizens and the Italian consulate, with candidates selected every five years. Wisconsin is one of eleven states under the jurisdiction of the Chicago consulate.

Decked out in a white tuxedo with a rose in his lapel, a dapper Alderman Tom Nardelli acted as grand marshal for Milwaukee's 1996 Carnivale. Nardelli represented his northwest side aldermanic district from 1986 to 2004 and ran for mayor in 2004. He launched his campaign in a major fund-raiser at the Italian Community Center. Among his many jobs on behalf of the city, Nardelli was chairman of the Common Council's Public Safety Committee and headed project development committee of the Wisconsin Center District. (Photo courtesy of Tom Nardelli.)

91

# *Your Voice In City Government*

Robert Jendusa represented the 36,100 citizens of Milwaukee's 8th ward from 1960 to 1973. While on the board, Jendusa served on the Council Rules Committee, Board of Estimates, and Central Board of Purchases. He was Common Council president from 1968 to 1972, before resigning to become the first executive director of Milwaukee's new convention center. While an alderman, Jendusa was chair of the water pollution committee, home improvement rackets investigating committee and the industrial development committee. Born May 14, 1921, he died January 24, 1975. Jendusa's wife was the delightful Provie Diliberti, member of another prominent Italian Milwaukee political family. Their children were Bobby Jr., Susie, Debbie, Sandy, and Larry. Bob Jendusa's uncle, Mike Jendusa, was also an alderman, of the old 23rd ward (now the 8th ward), from 1945 to 1956. (Photo courtesy of Dan Diliberti.)

Future Milwaukee alderman Mike D'Amato was four years old when he was photographed, ready for play in the alley behind his uncle Dominic Rossetto's Uniti Bar at 124 N. Water Street. With him are his brother Frank, six, and sister Franca. (Photo courtesy of the D'Amato/Rossetto families.)

It was party time at the Tracks bar for Mike D'Amato (center with tie) when he won his first aldermanic election in 1996. D'Amato went on to recapture his third aldermanic district seat in the 2000 and 2004 elections. Joining the celebration were his soccer buddies: Giovanni Zizzo (hoisting a champagne toast), Jose Rivera, Giovanni (John) Carini, and John Coleman (drinking). The men played for the Verdi club, named after Giuseppe Verdi, the noted opera composer. (Photo courtesy of the D'Amato/Rossetto families.)

Supervisor Daniel Cupertino Jr., or "Coop" to his friends, represented the 17th District, on the Milwaukee County Board from 1972 to 1996, when he died of a heart attack. His daughter, Lori A. Lutzka, who won a special election in 1974 and served until 2004, succeeded him. Here, Cupertino has a good laugh with Milwaukee Irish Fest's Paddy McFest, during a Courthouse promotional event in 1986. Cupertino was roasted in 1992 at a Columbus Day benefit for the ICC building program, featuring a Genovese fish fry dinner. (Photo by author.)

Daniel J. Diliberti was a Milwaukee County supervisor representing the 8th District from 1992 to 2004. While on the board, he was its vice-chairman and held numerous committee chairmanships. Diliberti was also active with the Wisconsin Counties Association, the National Association of Counties, the Southeastern Wisconsin Regional Planning Commission, and numerous other political entities. Prior to becoming a supervisor, Diliberti was a Peace Corps volunteer in Chile (1969-1971), assistant vice-chancellor of university relations at the University of Wisconsin-Milwaukee from 1976 to 1979, director of the Inner City Development Project-South from 1980 to 1983, and a policy and planning analyst for the County Board. (Photo courtesy of Dan Diliberti.)

Attorney John A. Fiorenza was named Marquette University "Law Alumnus of the Year" in 1992. He had received his bachelor's at MU in 1953 and graduated from the university's law school in 1956. After law school, Fiorenza was in private practice and was elected Brown Deer municipal judge from 1964 to 1966. He served as a Milwaukee County judge from 1966 to 1972 and became a reserve judge, a referee for the Board of Attorneys Professional Responsibility and a county court commissioner. Fiorenza was also president of the Milwaukee Bar Association in 1980. Over the years, he was active on many MU alumni boards and committees. (Photo courtesy of Marquette University archives.)

One never knows who will drop by for dinner, at least not at Mimma's Café at 1307 E. Brady Street in the heart of Milwaukee's old East Side Italian neighborhood. On this occasion, the guest was New York Mayor Rudolph Giuliani, who was visiting the city in the early 2000s. Here, Mayor Rudy pointed out something of interest to host Joe Megna, husband of restaurant owner Mimma Megna. (Photo courtesy of Girolama (Mimma) Megna.)

Justice Louis J. Ceci, the first Italian American to serve on the Wisconsin Supreme Court, sat on the state's highest bench from 1982 to 1993. He was also the first Italian American to be elected to Milwaukee County Circuit Court, in 1974, a post he held before being appointed to the Supreme Court. Two years later, he won a 10-year term. His 32-years of public service included two years in the State Assembly (1965-1966) and a stint as an assistant Milwaukee City attorney. Ceci was a longtime member of the Milwaukee chapter of UNICO and the ICC. Born in New York City, he came to Milwaukee before World War II to live with his brother, Dr. Gabriel E. Ceci. He enlisted in the Navy at age 17 and served as a radio operator in the Pacific theater, then returned to Milwaukee and received his bachelor's and law degrees from Marquette University. His parents, Louis and Philomena DiCristofara Ceci, emigrated from Maddaloni, a village north of Naples. (Photo courtesy of the Wisconsin Supreme Court.)

Judge John J. DiMotto, a former Milwaukee County assistant district attorney, was elected judge of the Milwaukee County Circuit Court's Branch 41 in 1990. He served in the criminal and civil divisions of the court and became presiding judge in the family division in 2003. A Milwaukee native, he is the older of two sons born to restaurateur/liquor distributor JohnDiMotto and his wife Anna Marie (pictured here on either side of he and his wife, Judge Jean DiMotto). His grandfather, Anthony DiMotto, and grandmother, Mary Marone DiMotto, came from the Basilicata region of southern Italy, and were married in Milwaukee. Judge DiMotto is a longtime Festa volunteer and is a member of the Pompeii Men's Club and the ICC. DiMotto is also a past president of the Milwaukee chapter of UNICO. His wife, Judge Jean W. DiMotto, was first elected in 1997, and has presided over criminal dockets. Proud of being Italian by marriage, she particularly values the Italian focus on family and children. She is also a nurse, the only nurse-judge in Wisconsin, and is a nationally renowned teacher of legal issues to nurses. She often swears in officers for the many Italian and nursing organizations in the city. (Photo courtesy of John J. and Jean W. DiMotto.)

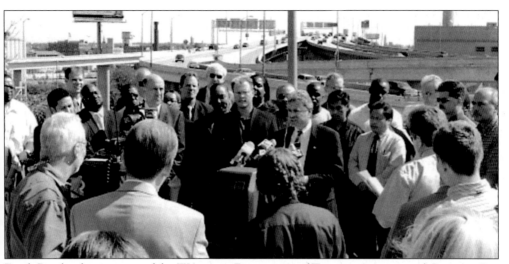

Frank Busalacchi, secretary of the Wisconsin Department of Transportation, joined Governor Jim Doyle, local officials, and community members in July, 2003, to announce plans to reconstruct the Marquette Interchange in downtown Milwaukee. Governor Jim Doyle appointed Busalacchi secretary of the Wisconsin Department of Transportation in January 2003. Busalacchi formerly was the secretary-treasurer of the Milwaukee Teamsters Local 200, one of the largest locals in the state. He began with the union as a business agent in 1979 and was elected president in 1991 and secretary-treasurer in 1994. Long active in community affairs, Busalacchi acted as president of the Summerfest Board of Directors and was the construction committee chairman for the Miller Park Baseball Stadium. Busalacchi was a member of the Southeast Wisconsin Regional Planning Commission advisory committee to the southeast freeway study, and a member of the Greater Milwaukee Committee. As secretary of Wisconsin DOT, Busalacchi leads one of the largest state agencies, with over 3,900 employees and annual budget of over $2 billion. He was honored for his civic work in a ceremony at the Italian Community Center on October 22, 2003. (Photo courtesy Wisconsin Department of Transportation.)

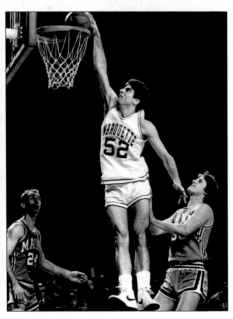

Marc J. Marotta demonstrated his ball-handling skills at Marquette University, where he was a three-time All-American. Those talents were valuable when he became secretary of the Wisconsin Department of Administration (DOA) in January, 2003, the first Italian-American to head a cabinet position in the state's 155 years. In addition to supervising his department, Marotta is an ex-officio member of the State of Wisconsin Investment Board, the University of Wisconsin Hospital Clinics Authority Board, and the Wisconsin Center District Board. Prior to his appointment, Marotta was a partner in the Milwaukee office of the Foley & Lardner law firm. He graduated from Marquette University in 1984, where he studied economics, political science, and English. Marotta graduated from Harvard Law School in 1987. (Photo courtesy of Marquette University archives.)

97

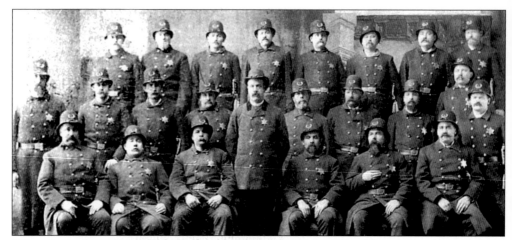

Milwaukee police officers serving on the city's South Side in 1884 were ready to hit the streets to ensure that the public was in good, safe hands. At this time, the average patrolman earned $960 a year, while a sergeant could make $1,200. A number of young Italian men joined the department by the turn of the century, reporting to Lieutenant Michael O'Connor, the drillmaster, who instructed the new officers in the proper uniform and gear. Each man was issued a star, rule book, and night stick, but had to purchase his own uniform and revolver. The trainee walked a beat with an older officer until certified for advancement. When considered qualified, he was assigned a beat and then began receiving a city paycheck. (Photo courtesy of Sgt. Ken Henning, Milwaukee Police Department.)

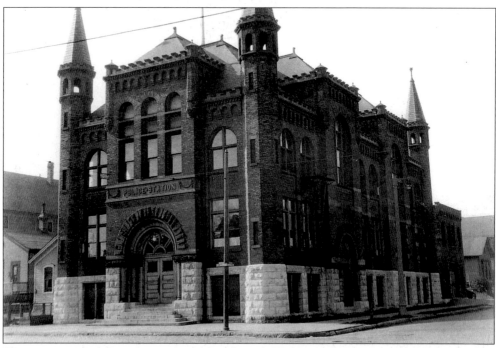

The imposing 2nd District station at S. 6th and W. Mineral streets was the hub of police activity on Milwaukee's South Side in 1932, with part of its jurisdiction being the old Third Ward and Walker's Point neighborhoods. The turrets and steeples were typical of stations of the day. (Photo courtesy of Sgt. Ken Henning, Milwaukee Police Department.)

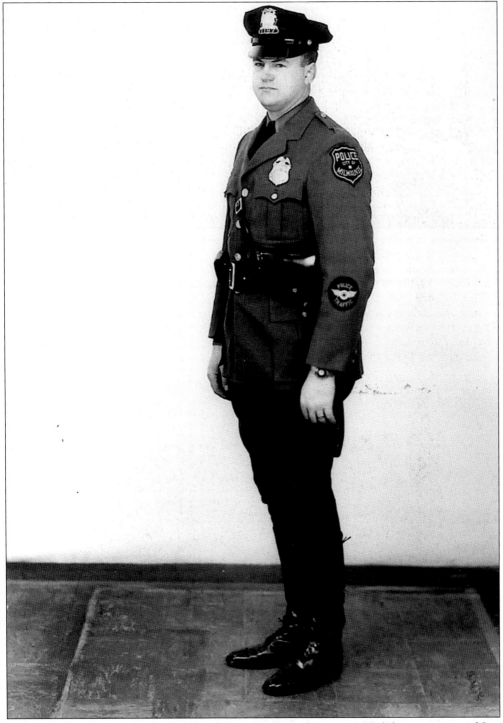

Patrolman Eugene Gascoigne showed off his summer uniform in 1955. (Photo courtesy of Sgt. Ken Henning, Milwaukee Police Department.)

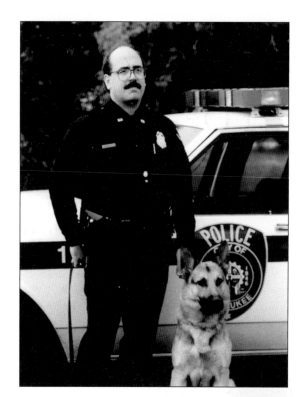

Police officer Donald Gaglione and Yelk are pictured here.

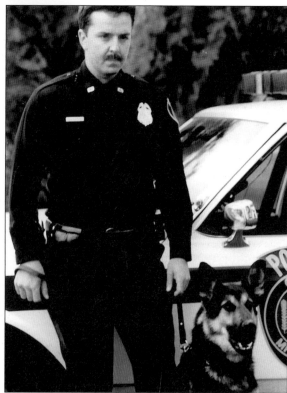

Police officer James Sanfilippo and Astor are pictured here. (Photos courtesy of Sgt. Ken Henning, Milwaukee Police Department.)

# Seven

# A WORLD OF ART

Italian Milwaukeeans are serious about their culture. In 1912, Francesco Spicuzza was a noted portrait artist and impressionist painter in Milwaukee. He was also known for his monochromatic pastel beach scenes and still lifes. On the music scene, Luciano Pavarotti appeared at a packed benefit concert for the Florentine Opera in 1992. But let's go back even deeper into the past to Rocco DeLorenzo, who was born in 1856 in Corleto, near Naples. He moved to the city in 1888, joining the DeBona string quartet, performing with the Ferrullo orchestra, playing background music for silent pictures, and teaching music. When tenor Enrico Caruso and composer Pietro Mascagni appeared in Milwaukee, DeLorenzo performed in their stage orchestras. DeLorenzo died at age 90, in 1946.

Milwaukee's fourth annual International Arts Festival in 2001 honored the Italians with concerts, architectural tours, art shows, lectures by such marvelous academicians as Professor Michela Montante, and a film series with movies by Roberto Rossellini, Federico Fellini, Michelangelo Antonioni, and Daniel Alegi. The event kicked off with a free exhibit of paintings by Italian Renaissance masters such as Ridolfo di Domenico Ghirlandaio, Bassano, Bellini, and Tintoretto at the Haggerty Museum of Art at Marquette University.

A far as theater goes, there must be proscenium genetics in the Nardelli family. Born to a father active in the old Milwaukee Players, and a mother who was a Warner Theaters' manager, Tom Nardelli also become active in the arts—well before he became a Milwaukee alderman. Young Tom appeared in such early 1960s productions as Salute to Broadway, directed by Tomi Castrovinci at Riverside High School, and A Room Full of Roses with the Norman Players.

Milwaukeeans tuned into the accordion music scene would have reveled to the upbeat sounds of Frank Camerata, Peter Orlando, and Frank Ricchio, who entertained at Milwaukee area clubs and in concert in the 1940s and 1950s. In the 2000s, they've enjoyed singer Guy Fiorintini, band leader/keyboardist George Busiteri, and guitarist Jim Eanelli of the group Salt Creek.

Other notable Milwaukee Italian musicians include Joe Millonzi, a self-taught high-energy performer whose band was hot stuff in the 1920s, playing at George Devine's Million Dollar Ballroom, the Wisconsin Roof, and Miller Hall at 8th and State streets. His group included Joe Aliota, Joe Caravella, Jack DeBenedetto, and Casper Reda. His son, Lawrence, went on to perform regularly at Caesar's Palace in Las Vegas. Emil Anello was a professional musician since high school, performing with dance bands at the Eagle's Ballroom or the old Wisconsin Roof Ballroom in the Wisconsin Theater Building.

Italian Americans are well represented in the sports world. Milwaukee even lays a friendly claim to football icon Vince Lombardi, who led the Green Bay Packers through its Golden Era, regularly playing in Milwaukee. While Lombardi never lived in Brew City, he often visited to give talks and participate in civic activities. Gridiron fans of the 1940s loved to watch the Packers' Tony Canadeo, who accounted for 8,211 total yards in offense, averaging 5.8 yards every time he touched the ball. He is a member of the Wisconsin Sport Hall of Fame.

Charles Balestreri, who died in 1993 at the age of 101, was one of the city's top boxers. A former light heavyweight champ, he was noted for clean left hooks that dazed such tough opponents as Louie Aveni. He worked for 55 years on the Milwaukee Road railroad before spending another 25 years at the West Allis Green market.

Enrico (Hank) Marino, a competitive bowler for more than 50 years, played for the Heil Products team in the 1930s. Considered one of the world's top bowlers, Marino was national singles champ from 1934 to 1938, and was named "bowler of the half century" by the American Bowling Congress in 1951. He was elected to the Wisconsin Sports Hall of Fame in 1958. Marino died in 1976.

The Romany Singers were a big hit on the Wisconsin music scene in the 1940s and 1950s. Under the direction of Gloria Rodriquez (left), the group regularly sang at the Wisconsin State Fair and at the WTMJ studios. At 5:30 p.m. on Sundays, the Singers were broadcast live on a program sponsored by the Miller Brewing Company. Among the group were a number of young women of Italian heritage, such as Virginia Francesca (seated in the first row, first left) and Josie Carrao (seated third from left). Anna Tarantino was second from left in the third row. Anna, who spent nine years with the Romany Singers, was known for her rendition of Schubert's "Ave Maria." In 1950, when she was 19, Anna performed the hymn at St. John's Cathedral during a Milwaukee Symphony benefit recorded for an album. In 2000, her sons, John and Joe SanFelippo, recorded her singing "Ave Maria" again, at a studio in Orlando, Florida, and put both renditions on a CD that was given to her extended family as a gift. A pupil at St. John's Cathedral High School, young Anna won a scholarship to the Wisconsin College of Music, and was often accompanied by her friend, pianist Norma Frinzi, sister of Dominic Frinzi, an avid opera fan and major supporter of the Italian Community Center. (Photo courtesy of Anna Tarantino SanFelippo.)

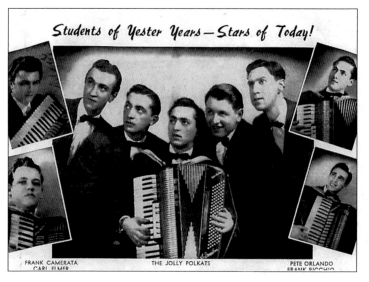

From 1948 to 1952, the Jolly Polkats were among the best dance bands around the Milwaukee area. Pictured from left to right are drummer Jimmy D'Amato, bassist Nick Tripi, Pete Orlando on accordion, guitarist Frank Balistrieri, and Joe Balestrieri on sax and clarinet. Note the different spelllings on the two last family names. (Photo courtesy of Frank Balistrieri.)

102

Peter and Cathy Balistrieri had the marvelous opportunity to meet musician Johnny Puleo and his Harmonicats around 1954. The band was playing at the Tradewinds Supper Club on 3rd Street between Wells and Kilbourn. (Photo courtesy of Frank Balistrieri.)

Frank J. Balistrieri, owner of the Italian Carretto, often brings out his musical instruments and sings a song. The Italian gift shop is located at 1689 N. Humboldt Avenue, in the heart of Milwaukee's East Side Italian neighborhood. Balistrieri has also been a restaurant owner and promoter, as well as a full time musician. (Photo by author.)

# ITALIANI!... TUTTI AL GRANDE SPETTACOLO

## PER LA PRIMA VOLTA NELLA COMUNITA' DI MILWAUKEE

# REMO GERMANI

### ED IL SUO COMPESSO

LA BRAVA

# Dori Ghezzi

IL MAGO DELLA TROMBA

# Nini Rosso

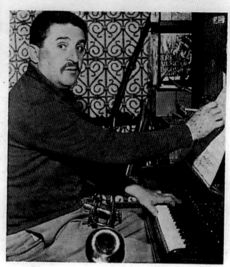

*SUBITO DOPO LO SPETTACOLO TRATTENIMEMTO DANZANTE CON*

# THE SICILIAN SERENADE

# DOMENICA, 16 MARZO, 1969 - ore 2:30 P.M.

The EAGLES CLUB - 2401 W. Wisconsin Ave. - Milwaukee

UNICO SPETTACOLO                    ~                    $5.00 A Persona

Una Presentazione di JOSEPH MANGLARDI
In collaborazione con i Produttori dei Programmi Radio Italiani:
**John Aiello,** Kenosha, Tel. 652-7193 ~ **Giorgio Argondizzo,** Milwaukee, Tel. 482-0188

A musical program featuring singer Remo Germani, Italian television star Dori Chezzi, and trumpeter Nini Rosso was held Sunday, March 16, 1969, at the Eagles Club, 2401 W. Wisconsin Avenue. The show, a presentation of Joseph Maglardi, in collaboration with Milwaukee's Giorgio Argondizzo and Kenosha's John Aiello, was sponsored by WQFM-Radio. (Flier courtesy of Giorgio Argondizzo.)

Milwaukeean Anthony (Duffy) Tarantino was an integral member of the wacky Spike Jones and the City Slickers, which delivered its musical comedy with all the verve of a wartime Big Band sound. As with others in the popular group, Duffy was not averse to wearing a wig or even playing a toilet seat. Spike, Duffy, drummer Joe Siracusa, and the rest of the gang mixed the highbrow with the lowbrow comic via true musical skills through the 1940s and into the 1960s. Among their classics was an offbeat 1945 rendition of *The Nutcracker Suite* and the 1953 *Spike Jones Murders Carmen*. In this photo, Duffy was caught relaxing between tours in January 1966. His father Carlo Tarantino was born in Sicily, while his mother Anna was born here in Milwaukee. The family lived for years in Brady Street's Italian neighborhood. (Photo courtesy of Anna Tarantino SanFelippo.)

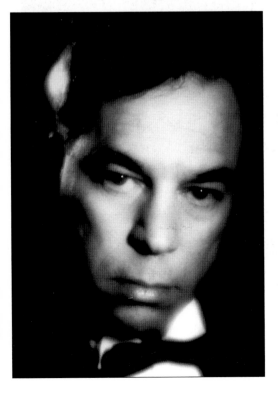

Jerry Grillo is one of Milwaukee's most popular jazz singers, often performing with the Nick Contorno Orchestra as well as soloing with his own combos. Music was always part of his family when growing up in Hibbing, Minnesota, where his grandfather, James Grillo, had emigrated in the late 1890s from Calabria to work in the iron mines. His father, Dominic, was also a miner for 40 years. Grillo came to Milwaukee in 1966 to teach school and retired as a Milwaukee public school business teacher in 1999. In the 1970s, his band, Sweet Earth, modeled itself after the Tony Orlando & Dawn sound. Since 1994, Grillo has recorded six CDs. Among his original compositions, Grillo co-wrote "Lonely" with pianist Roe Fosco. (Photo courtesy of Jerry Grillo.)

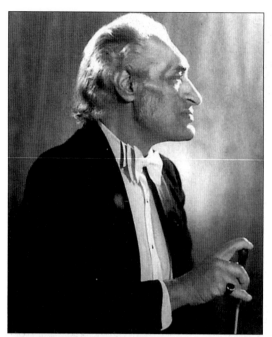

John-David Anello Sr., one of Milwaukee's premier conductors, grew up in the Third Ward and went on to found the Florentine Opera, the Milwaukee Pops Orchestra (which morphed into the Milwaukee Symphony Orchestra), and the Music Under the Stars program at Washington Park. His mother, Antoinina Anello, was always listening to opera. His father, Benedetto Anello, was a butcher. A scholarship in his name is available through the Milwaukee UNICO chapter for Wisconsin music students 14 to 22 years of age of Italian heritage. He and his wife, Josephine Doria Anello, had two children, Dolores (Dee) and John-David Jr. (Photo courtesy of the Florentine Opera, from *Musical Memories: The Memoirs of John-David Anello, Sr.*)

Daniel N. Forlano was music director of the Milwaukee Ballet and Waukesha Symphony Orchestra. He died at age 51 in 1995 after collapsing during a rehearsal for the ballet's 25th anniversary at the Performing Arts Center. A native of Philadelphia, he studied at the Settlement Music School there, and then went on to the Juilliard School in New York and for other studies elsewhere. Forlano began his career with the Pennsylvania Ballet and came to Milwaukee in 1976. He conducted numerous world premieres, including the company's commissioned "Virgin Forest" and "Stepping Stones." Forlano was named head of the Waukesha symphony in 1980. (Photo courtesy of the Waukesha Symphony Orchestra.)

Early in the 1970s, longtime Milwaukee broadcaster Giorgio Argondizzo proudly posed with his son Vincente Mario. The elder Argondizzo began his radio career on WTOS in 1966, moving to several other stations in the area over the years. Argondizzo's show, *La Voce d' Italia* ("The Voice of Italy") has been aired Sundays on WMSE-FM since June 4, 1980. He was born in San Marco Argentano, in the Cosenza area of Calabria. In 1962, after living in Switzerland for five years, Argondizzo came to Wisconsin where he had relatives living in South Milwaukee. His son, Vincente, was born in 1966 and became an international relations manager for a company in Bologona. Argondizzo and his wife Rosina have another son, Pietro Giorio, who works as a translator in Illinois. (Photo courtesy of Giorgio Argondizzo.)

Drummer/percussionist/actor/writer/ singer/songwriter Victor DeLorenzo helped make the Violent Femmes Milwaukee's most significant rock band in the 1980s and 1990s. The group still performs stateside and internationally. The Femme's acoustic punk has been a major creative influence on many of the city's other budding young artists, recording on Slash Records, Rhino, and other labels over the years. Victor manages a studio on the city's East Side and also records as a solo artist and with other musicians, and also often performs in theater and in films. In addition to rock music, Victor also has a jazz band: the Ha-Ha Potato. The first of the DeLorenzo family came to Racine from Castellammare del Golfo, Sicily, in the late 1800s, with Victor moving to Milwaukee to attend the University of Wisconsin-Milwaukee in 1974. (Photo courtesy of Victor DeLorenzo.)

Michael A. (Michael D) D'Acquisto is a noted Milwaukee comic whose great-grandfather Nick D'Acquisto emigrated from Porticello, Sicily, just after World War I. The elder D'Aquisto became a maintenance employee at a Milwaukee factory and his son John was a punchpress operator and union steward at the Nesco Company when it was located on St. Paul Avenue. John's son Mike was an all-around utility worker at Falk Corporation for 37 years. The fourth-generation D'Acquisto is also a professional signmaker, working with custom neon in addition to his stand-up comedy work. As well as traveling to clubs and shows around the country, Michael D is the emcee for an ongoing comedy show at Milwaukee's Potawatomi Casino, produced by Joe SanFelippo. (Photo courtesy of Michael A. D'Acquisto.)

Born on Milwaukee's East Side on August 2, 1955, renowned actor/singer Anthony Crivello is a regular on Chicago, Los Angeles, and New York stages. Crivello's performing honors include a 1993 Tony Award for Best Supporting Actor in a Musical as the original Valentine in Hal Prince's *Kiss of the Spiderwoman*. Here, Crivello is showing off the award to his mom Josephine, and dad, Hank Crivello. In 1996, young Crivello won the Joseph Jefferson Award for Best Leading Actor in a Musical, for the pre-Broadway showing of *The House of Martin Guerre* at the Goodman Theater in Chicago. He also appears regularly in television productions, beginning his broadcast career in 1968 on the daytime series *One Life to Live*. Also in television, he co-starred in Tele-films' *Dillinger and Capone* (Mystfest 95, Italy), with Martin Sheen and F. Murray Abraham in the title roles. Crivello's film credits include: *The Alien Hunter, Independence Day,* and *Twisted.* (Photo courtesy of the Crivello family.)

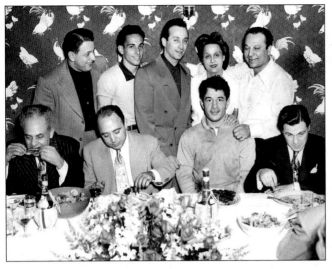

In 1950, a reception was held for middleweight Rocky (The Rock) Graziano at Chico's barbecue restaurant on Farwell Avenue. The Manhattan-born champ, whose real name was Thomas Rocco Barbella, was in town for a bout with Brooklyn boxer Vinnie Cidone. The match was held on May 9, the first sporting event at the new Milwaukee Arena. In the fight, Graziano scored a fourth-round TKO over Cidone, in front of a crowd of 12,813. Restaurant owners Frank LaGalbo and his wife, Babe, are in the back row, right side, with Joe Regano (Babe's brother) next to her. Also in the back row (far left) is Frank J. Balistrieri. In the front row, eating ribs (far left), is Sam Ferrara, owner of the Peacock Bar, a popular watering hole at Van Buren and Lyon streets. The others in the photo are unidentified. There were also a number of great boxers in the Milwaukee area, who made names for themselves. Among them were Battlin' Tony Dentice, a 1902 star. During the 1930s, 1940s, and 1950s big names were: brothers Tony and Mario Bruno, as well as Johnny and Frankie Gaudes, and their brother Sid (Kelly) Gaudes, Charlie Busalacchi, Gus DiSalvo, Charlie Balistreri (who lived to be over 100 years old), Sam Cicerello, and Tony Olla. Richie Mitchell's gym at 3rd and Wells above the Johnny Walker clothing store turned out stellar fighters such as Tommy Dentice and Carmen Caputa. Fights were regularly held at the Milwaukee Athletic Club, the Eagles Club, and the old Riverview hall at Cambridge and North. *Milwaukee Journal* cartoonist Frank Marasco sketched marvelous portraits of Graziano before that 1950 bout, works now archived at Marquette University. (Photo courtesy of Frank Balistrieri.)

Tom Marchese had a major impact on Wisconsin auto racing as a sports promoter and track manager. At the age of 5 in 1904, he and his family left Sicily and sailed to the United States. Living in the Third Ward, he left school in search of work at age 11. He and his brothers—Carl, Joe, Tony, and Tudy—took over a South Side garage and began working on race cars in addition to their regular mechanics. In 1929, Marchese began handling race promotions at State Fair Park, and remained there for the next 43 years. (Photo courtesy of the Wisconsin State Fair Park.)

Showing off his great bocce form, Dominic SanFelippo was joined in a spirited match in the early 1970s at a picnic hosted by the Pompeii Men's Club. The game was held at Jackson Park, with families of club members entering into the fun. Games are now regularly held at the Italian Community Center and at Festa Italiana. (Photo courtesy of Anna Tarantino SanFelippo.)

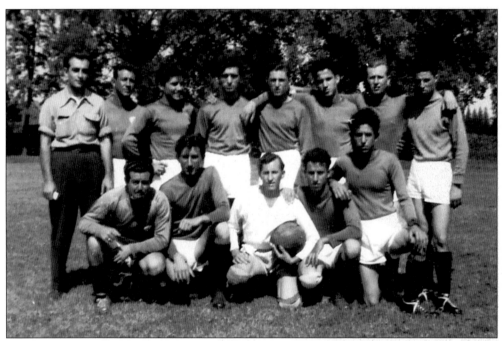

The Verdi Soccer Club gathered for a team photo in the late 1940s. Pictured from left to right are: (front row) Sam Alaimo, Tom Lococo, Jack Corrao, Albert Lococo, and Joe Apparito; (back row) Nick D'Amato, Peter Vella, Tom Vicini, Isidore Peccoraro, Tom Alioto, Bob Seidita, Andrew Corrao, and Santo Alioto. (Photo courtesy of the Vella family.)

Lawrence Baldassaro is a second-generation Italian American whose four grandparents emigrated from the Campania and Abruzzo regions of Italy. A native of Chicopee, Massachusetts, he has been a professor of Italian at the University of Wisconsin-Milwaukee since 1972, and director of its Honors Program since 1995. He has published numerous articles on Dante and other aspects of Italian literature and culture in American and Italian journals. In 1991, he directed an oral history of the Italians in Milwaukee. In addition, Baldassaro is the co-editor of *The American Game: Baseball and Ethnicity* (Southern Illinois University Press, 2002), and editor of *Ted Williams: Reflections on a Splendid Life* (Northeastern University Press, 2003). He is now writing a history of Italian Americans in major league baseball. In this photo, Baldassaro is interviewing baseball great Ted Williams in 1982 in Winter Haven, Florida. (Photos courtesy of Lawrence Baldassaro.)

Third baseman Sal (Salvatore Leonard) Bando played for the Milwaukee Brewers from 1977-1981. His 40-year baseball career took him from college days at Arizona State University to becoming top executive for the Milwaukee Brewers. Bando was an All-Star in 1969, and from 1972-1974. After his playing days, Bando was general manager of the Brewers from 1988 to 1999. Bando's paternal grandparents were born in Millatello, Sicily. His maternal grandparents were from Bellarosa, Sicily. The grandparents of Bando's wife, Sandy, came from Sorento and Naples. The couple came to Milwaukee in 1977 and immediately became active in the local Italian community, with Bando becoming fund-raising chair for the Italian Community Center. He was also elected into the American Italian Renaissance Foundation's Sports Hall of Fame 1996. In the 2000s, Bando was an investment counselor. (Photo courtesy of the Milwaukee Brewers.)

Tony Migliaccio has been with the Milwaukee Brewers organization since he was a young batboy in 1978. He became a clubhouse attendant in 1981, assistant clubhouse manager from 1981-1985, and he became equipment/clubhouse manager in 1986. A graduate of Pius High School, he was a catcher at Central Arizona College and eventually graduated with a degree in communications from the University of Wisconsin-Milwaukee in 1985. Young Migliaccio's grandfather Pasquele, a native of Sicily, had an Italian import grocery business on Commission Row and then owned Como's Restaurant with his sons Louie, Joe, and Angelo. The restaurant was a favorite with many of the old Milwaukee Braves baseball team. After retiring from the car sales business, Migliaccio's dad, Joe, also worked part-time in the Brewer's mailroom. His mom, Lucille Sasso Migliaccio, has family roots in Northern Italy. Migliacchio and his wife, Linda, have one young son, Joel, who also loves baseball. (Photo by author.)

Joe Gagliardo of Rice Lake was a featured member on the Marquette University Golden Avalanche football team. He was an outstanding tackle in the annual Marquette-Madison grudge match in 1935, in which the Milwaukeeans almost held the University of Wisconsin to a scoreless tie. But he was unable to block a well-aimed place kick by Badger guard Mario Pacetti, who kicked a field goal just as time was called in the game, enabling Madison to win, 3-0. Gagliardo was a 1937 graduate of the College of Journalism. (Photo courtesy of the Marquette University archives.)

112

# *Eight*
# ANSWERING THE CALL

Since most Italians who came to Milwaukee arrived after the 1880s, few had much earlier opportunity to serve in the military, become police officers, or join a fire department. However, World War I drew in numerous Milwaukeeans of Italian heritage. Italian Milwaukeeans were eager to demonstrate pride in their adopted homeland. In 1917, Tom Aliota chose the Navy, while Steve Zambito selected the Army. In one snapshot, Tony Puliafito, was ready for action, wearing a gas mask with bayonet at the ready. Another poignant photo has Puliafito's penned message, "to my sweetheart Marie."

Dozens of Italian Milwaukeeans also answered the call to arms in World War II. Charlie Gumina posed proudly outside his 94th Division headquarters company day room in 1940, ready to show the folks at home he was ready to protect them. Throughout the war, Gumina fought with distinction in Europe and returned to Milwaukee to raise a family. Anthony T. Alioto, an aviation ordnanceman first class, served in the South Pacific, fighting his way across the Solomon Islands and the Bismarck Archipelago from July, 1943, to December, 1944.

The names go on and on. The Air Corps drew Joe Ninfo and Joe D'Amato. Charles Isadore Fricano joined the Army, (Queenie) Oliva marched off with the Marines, and Anthony Alberti selected the Navy. Sam, Joe, and Sal Cefarlia showed off their brotherly grins in a 1943 portrait.

Entire neighborhoods seemed to enlist. Ten young men from the Sportsmen's Club put aside their red club sweaters and joined the military in 1943, serving on fronts around the world. These men, all of whom grew up on the Lower East Side and attended Lincoln High School, often wrote to each other during the war. The club was organized in 1936. Three sets of brothers were in the group, including Sargeant Anthony J. Russo and Private Ted Russo of N. 4957 Newhall Street; Privates Sebastian and Nicholas Corriere, 2307 N. Booth Street; and Corporal Joseph Torcivia and Private Peter Torcivia, 400 E. Lyon Street. Others were Pfc. Joseph Canistra, 1428 N. Jefferson Street; Pfc. Joe Ingurio, 1511 N. Astor Street; Private Anthony Corrao, 333 E. Lyon Street; and Corporal Sammy Caruso, 1437 N. Milwaukee Street.

In 1944, Lieutenant Giuseppe Zingara was one of the last mounted cavalry officers commissioned by the Army as the military finalized its switch from horses to motorized vehicles. On leave from Fort Riley, Kansas, in January 1944, he visited hometown Milwaukee. Resplendent in riding boots and wide breeches, he put his arm around his mom, Congetta. Dad, Giuseppe, proudly laid his hand on his son's left shoulder.

Not only the men served. Many Milwaukee women of Italian heritage answered the call to military service in World War II. Among them were Jo Gagliano Brasile, a proud member of the Women's Army Corps, and Sandy Cianciolo.

The roster of honorees extends through Korea and numerous other battlefields up through Afghanistan in 2002 and the Iraqi war that started in 2003. Many Milwaukeeans of Italian heritage received medals and other honors for their military service. Sebastian H. (Pat) Corriere was given a distinguished military medal from French resistance officials in a 1993 ceremony in Duerne, France. Corriere was part of the U.S. Army Air Corps' 801st 492nd Bombardment Group, which operated major resistance missions in France and elsewhere in Europe during World War II. Back home in Milwaukee, Corriere belonged to the ICC, the Holy Crucifix Society, and the Pompeii Men's Club, as well as being a top bocce player.

The ICC established a Military Honor Roll Committee in 1993. Under the supervision of Dominic Frinzi, its members were commissioned to find a suitable memorial for area veterans of Italian descent. This eventually led to the building of the American Veterans Memorial, with ground broken on March 9, 1996, at the entrance to the ICC. The fund-raising chair for the project was Rosario Spella and the monument construction manager was Phil Purpero. Campaign co-chairs were Joseph Campagna, Jr. and Vincent B. Emanuele. Committee members were Sebastian H. Corriere, Anthony J. Gazzana, Anthony Guardalebene, Joseph Ninfo, Charles Raffaele, and Carmen Zingara. The memorial was dedicated on Memorial Day, 1996.

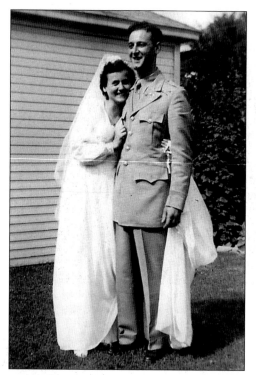

Ruth and Giacomo (Jim) Diliberti were a loving couple when they married on July 10, 1943, just before Jim was sent off to war. He eventually retired in 1963 as a lieutenant colonel in the Army Reserves. Diliberti worked primarily stateside during World War II testing chemical weaponry. After the war, Diliberti worked at Milwaukee's main post office where he retired as its employment officer in 1975. He grew up on Milwaukee's South Side, in the neighborhood around 35th and Scott along with the Jendusas, the Vitales, and numerous other Italian families there who then sent their sons and daughters off to the military during World War II. (Photo courtesy of Dan Diliberti.)

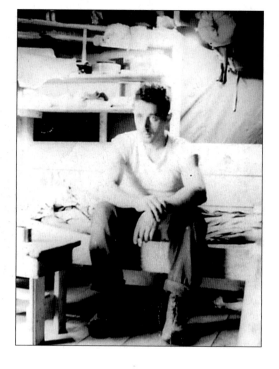

There was a cold wind blowing across the Aleutian Islands in 1944 when Sam (Salvadore) Diliberti was stationed there as a young shipfitter/second class with the Navy Construction Force (Seabees). The bulge in the tent behind him is due to the snow piled outside. Sam returned safely from the Navy to run a plumbing firm at 3409 W. National Avenue for 30 years. (Photo courtesy of Dan Diliberti.)

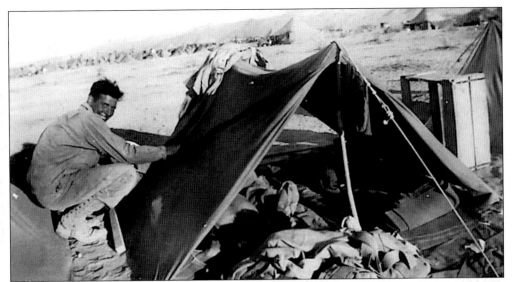

Cpl. Tony Mastrogiovanni straightened out a tent as a buddy slept inside somewhere in training camp during World War II. After the war, Mastrogiovanni and his brother Joe worked together at the Milprint Company for many years. (Photo courtesy of Rose Mastrogiovanni.)

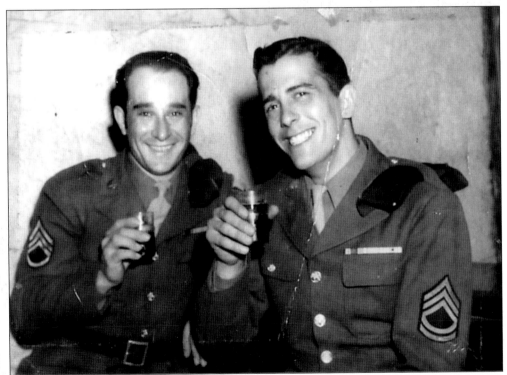

Even Army duties couldn't preclude drinking a wartime toast. Ted (Salvatore) Mastrogiovanni (left) joined a buddy named Carl for a drink sometime during World War II. Mastrogiovanni enlisted in the service in 1939 and finally retired 37 years later. Dying in 1990, he is buried in Fort Leavenworth National Cemetery, Kansas. (Photo courtesy of Rose Mastrogiovanni.)

Joseph A. Iannelli was born in Milwaukee on July 15, 1926, and enlisted in the Marine Corps on October 25, 1943, at the age of 17 with his buddy Tom D'Acquisto who lived about block from his house. Joe took his basic training in San Diego, weighing in at only 118 pounds, although the minimum was 125. Writing down the latter weight, Iannelli's recruiting sergeant said, "Don't worry. The Marine Corps will put some more pounds on you." Part of a 60mm mortar crew, Iannelli fought on Tinian in the Northern Mariana Islands and saw action in Saipan, as well as participating in a fake landing on Okinawa to divert the attention of the Japanese. He was discharged at the Great Lakes Naval Training Center, Illinois, on March 4, 1946. (Photo courtesy of Joseph Iannelli.)

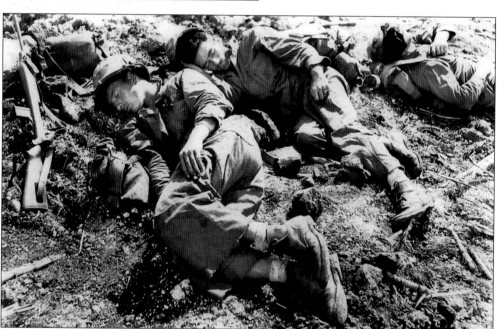

Amid fierce fighting on Tinian in the summer of 1944, Joseph A. Iannelli (left) took a well-deserved break. He had many near misses in the fierce fighting and his family back home was once mistakenly told he was killed in action. Despite 328 dead and 1,571 wounded, Iannelli and his fellow Marines eventually took control of the 10-mile-long island that had been defended by more than 9,000 dug-in Japanese. Tianan eventually became the launch site for planes carrying the atomic bombs that destroyed Hiroshima and Nagasaki. Iannelli was among the first Marines occupying the devastated Nagasaki. He toured the dusty, bombed-out area, with the queasy feeling that he and his pals were being used as guinea pigs in radiation testing. (Photo by US Marine Corps, courtesy of Joseph A. Iannelli.)

Army Sargeant Joe Glorioso was visiting his pal Corporal Milton Rubin in Mount Vernon, New York when this photo was snapped just before the two were shipped to Europe during World War II. At age 23, Glorioso was an official Army headquarters recorder witnessing the German surrender in France. (Photo courtesy of Joe Glorioso.)

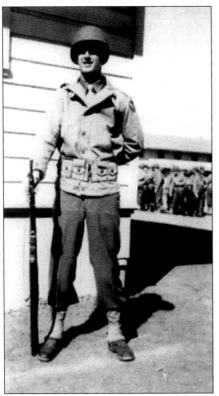

Louis Romano, son of Liborio and Mary Romano, cut a striking figure during training camp in World War II. After service, he taught in Shorewood and became director of Instruction in 1954, with the title of assistant superintendent added later. Romano introduced modern mathematics in kindergarten through high school and started the first summer enrichment programs for elementary and junior high pupils. Romano also co-authored *Gertie the Duck*, a children's story translated into five languages, as well as seven professional books on education. Romano left Shorewood in 1965 to become Superintendent of Schools in Wilmette, Illinois. From there he joined the faculty of Michigan State University. Romano received the Shorewood school system's Tradition of Excellence award in September of 2003. (Photo Courtesy of Betty Puccio.)

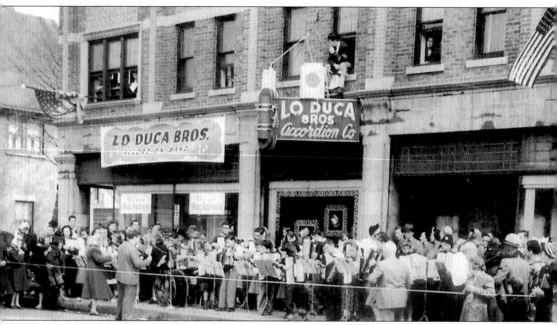

A crowd gathered around a student band playing in front of the Lo Duca Bros. music store on 24th Street and North Avenue at the end of World War II, celebrating a visit to Milwaukee by General Douglas MacArthur. Note that the youngsters are all playing accordions under the direction of Thomas Lo Duca. He founded the firm with his brother Guy in 1941, now operated by their sons and grandchildren. Over the years, the firm evolved into a source for consumer electronic accessories, musical instruments, imported and domestic wines, and cooking and seasoning oils. Its headquarters are in New Berlin, Wisconsin. The Lo Ducas' parents immigrated to Milwaukee from Milazzo, Sicily. (Photo courtesy of Vincent James Lo Duca.)

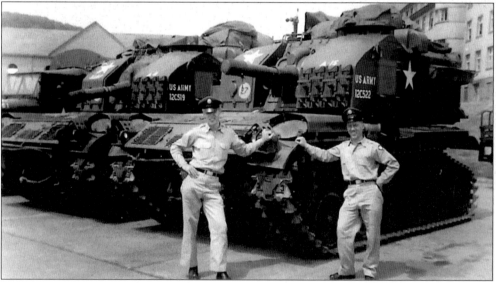

From 1959 to 1962, Mike D'Acquisto (right) was an E4 serving with an Army artillery and fire direction unit stationed in Gelnhausen, Germany. This photo was taken on the day he arrived overseas. The soldier with him is unidentified. (Photo courtesy of Michael A. D'Acquisto.)

Navigator/bombardier Pasquale (Pat) Marcella stood in front of his B-26 fighter-bomber in Pusan, Korea, during the Korean War. After college, Marcella joined the military in December 1951, and served overseas from 1953 to 1954. He specialized in night interdiction, flying from 6,000 to 10,000 feet on bombing and strafing runs. The day the truce was called, he was visiting his brother, Tony, a tech sergeant in the artillery near the front lines north of Seoul. After six years of active duty with the Air Force, Marcella joined the Air National Guard and served for another 30 years. He retired as a lieutenant colonel with Milwaukee's 440th Airlift Wing at Milwaukee' General Mitchell International Airport. (Photo courtesy of Pasquale (Pat) Marcella.)

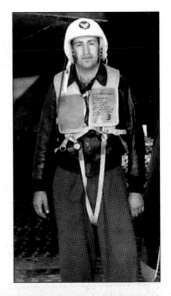

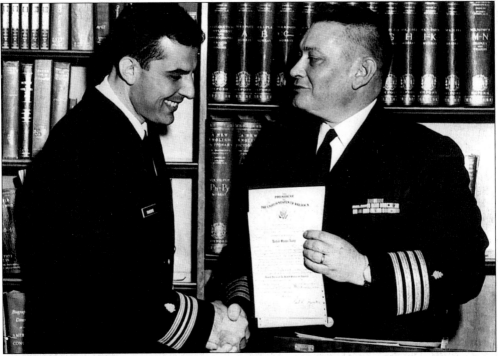

In 1968, Dr. Ralph Franciosi received a presidential citation from the commanding officer at the US Naval Hospital at Bethesda, Maryland. He received his award for research accomplishments in discovering how Group B Streptococcus infects newborns. At Seton Hall College, Franciosi also received an Army Reserve Medal as an outstanding cadet. He completed medical school and was board-certified with an emphasis on various types of pathology, including pediatrics. Franciosi served in the Navy from 1967 to 1969 at Bethesda where his positions also included becoming chief of autopsy service. Franciosi then worked at hospitals in Colorado and Minnesota before coming to Milwaukee in 1988 as director of pathology and laboratory medicine at Children's Hospital of Wisconsin. (US Navy Photo, courtesy of Dr. Ralph Franciosi.)

Milwaukee-born Vincent James Lo Duca, son of Thomas and Santa Lo Duca, was promoted to colonel in the U.S. Air Force Reserves in 1995, making him one of the highest-ranking Air Force officers in Wisconsin. At the time, he was commander of the 34th Mobile Aerial Port Squadron based at General Mitchell International Airport. He was then assigned to a liaison officer post with the Air Force National Security Emergency Preparedness Office, representing the Air Force's midwest region to the Federal Emergency Management Agency. Lo Duca holds business and law degrees from Marquette University and also is president of Lo Duca Bros., a musical instrument and wine importing company. (Photo courtesy of Vincent James Lo Duca.)

Sargeant Tom Dentice has been a member of the 440th Airlift Wing since 1985, after completing four years of active duty in the Marines. Tom is a loadmaster, responsible for restraining cargo and air dropping loads from the huge C-130s based at General Billy Mitchell International Airport. He has flown on mercy and relief missions in Latin and Central America and combat missions in Desert Storm, Bosnia, and Iraq. In February 2004, he and his crewmates delivered supplies to earthquake-ravaged Iran. When he is not flying, Tom is a journeyman electrician. Tom's great-grandparents, Thomas and Louise Cannariato, came to the United States from Allesandria della Rocca, Sicily, in the early 1890s. His grandfather, Anthony Cannariato, was a long-time resident of Milwaukee's East Side. Tom's nephew Tony followed in his uncle's footsteps by joining the Air Force in 2003. Tom's cousin, Vince Leto, is also a reservist at the 440th. The photo shows Tom on a recent Middle Eastern mission carrying a flag that ordinarily is displayed in his front yard. He always carries it with him when on a mission. (Photo courtesy of Tom Dentice.)

# Nine

# FESTA ITALIANA, "A REUNION"

*After the urban more-or-less renewal of the old Third Ward in the 1950s and 1960s, the Italian community sought a way to celebrate its past and encourage its young people to look forward to a bright future. Thus was born the idea of Festa Italiana, launched in 1978 to become one of North America's largest Italian cultural events. The event involved countless volunteer hours of planning, replanning, and project development. Festa is a reunion, an explosion of fun, a touch of the "good old days," and a wonderful entertainment venue.*

*Where else could Milwaukeeans see the Sbandieratori Casventum flag throwers from San Gemini, Italy, or the Canterini di Brolo folk dancers? Or take in the likes of singers such as Johnny Desmond, Liza Minnelli, Dick Contino, Nancy Sinatra, Tony Bennett, Ricci Martin, and Nelson Sardelli? Or laugh along with comedians such as Pete Barbutti, and watch chef Nick Stellino in action?*

*Several Third Ward reunions were held in the 1970s. So the desire to get the community back together was still strong even long after the neighborhood was gutted. In 1974, The Milwaukee Sentinel interviewed Anthony Guardalabene, owner of Guardalabene & Amato Funeral Home, about those days, "No phone book was needed to look up names. Word of mouth and remembering who lived next to whom in the Third or First wards was all we needed to compile this list," he said of a two-inch thick book of names and addresses of Italian Milwaukeeans.*

*"The festa should bring back happy memories of the old days," Theodore Mazza, who helped found UNICO and was the unofficial historian of the Italian community for years, was quoted as saying in The Milwaukee Sentinel in 1978. In the same article, Joe Glorioso asked, "When we get together, why should we have to go to the Pfister or the Marc Plaza. Why shouldn't we have a place of our own?"*

*Such thoughts led to a meeting of Italian community leaders on February 21, 1978, to establish a traditional festival. The goals were to raise money for the Italian Community Center, reunite the community, and share traditions with the broader public. The boards of directors of the Pompeii Men's Club, the Men of UNICO, and the Ladies of UNICO gave the ICC the seed money to put on the event August 5 to 7 of that year. Headquarters were established at 816 E. Brady St. Even with only months to plan and organize, thousands flocked to the Summerfest grounds for that first Festa. Paul Iannelli and Tony Machi were among those spearheading the effort to launch Festa.*

*"Festa Italiana is a wonderful thing in itself, but it is just part of a beautiful dream started last spring by a handful of people," T.J. Bartolotta said the following year, quoted June, 1979, in the premier issue of The Italian Times. "It shows that individuals with determination and vision can still make things happen." Bartolotta was the newspaper's editor-in-chief, with Angelo Castronovo as managing editor.*

Looking toward the future, the Zizzo Group Advertising and Public Relations firm designed a new logo for Festa Italiana in 2004. (Courtesy of Festa Italiana and the Zizzo Group Advertising.)

Attorney William Anthony Jennaro, a former Milwaukee county Circuit Court judge, was president of the Italian Community Center in 1994, succeeding attorney Dominic H. Frinzi. Jennaro was born in the old Third Ward, son of William and Florence Vitucci Jennaro. Jennaro received a law degree in 1968 from Marquette University. He was an assistant district attorney from 1968 to 1970 and thereafter set up the Children's Division public defender program in 1970. Jennaro was elected to the circuit court in 1972 and re-entered private practice in 1984, but remained a reserve judge. Among his membership in numerous law societies, Jennaro belongs to the Justinian Society, made up primarily of Italian American attorneys and judges. He has been a member of the ICC since 1974, and twice served on the board (1983-1985 and 1992-1994) prior to his election as president. Jennaro and his wife, Rita Carini Jennaro, have two children, Mario and Lisa. He notched his first hole-in-one while on vacation in Arizona just before serving as 1994 ICC Carnevale King. (Photo courtesy of William A. Jennaro.)

From 1979 to 1996, Anna SanFelippo operated "Galia Semenza," a nut stand at Festa Italiana. In 1994, her granddaughter, Angela Bartolotta, helped Anna in the booth. Anna also belongs to the Pompeii Women, the Italian Community Center, and the Catholic Daughters of the Americas. (Photo courtesy of Anna Tarantino SanFelippo.)

Betty Puccio and the late Sergio Franchi enjoyed each other's company at Festa Italiana in The Pastabilites booth. The singer performed at Festa for many years and loved to wear his Festa hat. Called by critics as "one of the greatest romantic tenors of the 20th century," Franchi died of cancer on May 1, 1990. Franchi's father was Neapolitan and his mama, Genovese. One popular story told how he used to joke, "From the waist up, I'm Neapolitan" (pointing to his heart); "from the waist down" (pointing to his pocket), "I'm Genovese!" (Photo courtesy of Betty Puccio.)

Puccio's Pastabilities always did a booming business at Festa Italiana, one of the many excellent food booths on the grounds serving generous portions of spaghetti and meatballs, among other Italian goodies. (Photo courtesy of Betty Puccio.)

Nicholas Joseph (Nick) Contorno was music director of Festa Italiana from 1982 to 1998. He grew up on Milwaukee's South Side in the old Town of Lake, near what would eventually be an expanded Mitchell International Airport. Since 1968, he has been music curriculum supervisor and director of bands at Marquette University. In addition, he is a composer and an active professional musician who has performed with Natalie Cole, Manhattan Transfer, Vic Damone, Johnny Mathis, Dinah Shore, and other major performers. (Photo courtesy of Nick Contorno.)

Mary Costa Contorno, mother of musician/band leader Nick Contorno, was ready to roll in a golf cart at the 1984 Festa Italiana. Her husband, Nicholas Contorno Sr., was a longtime charge attendant at the Milwaukee County Institutions. (Photo courtesy of Nick Contorno.)

Members of the Holy Crucifix Society readied a float for a procession at Fest Italiana in the early 1980s. The group of Italian men actively participated in many such religious observances over the years. (Photo courtesy of Joe Glorioso.)

The Pompeii Men's Club is always ready to serve the community, and turns out in force for each Festa Italiana. (Photo courtesy of Frank Balistrieri.)

Patrolman Ray Monfre was one of the many Milwaukee police officers of Italian heritage working the Fest grounds in 2004. Also on the job that year was police captain Anna Ruzinski (D'Amato-Catanni), who shared cantor roles at Festa's Sunday mass, along with former Aldo Tom Nardelli. (Photo by author.)

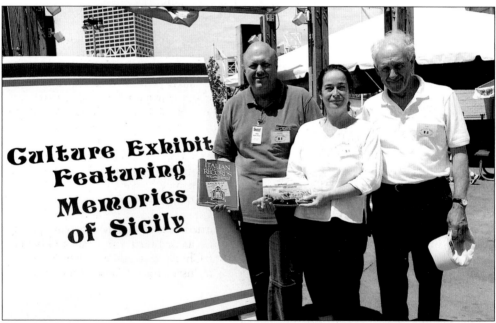

Visitors to Festa Italiana always have the opportunity to learn more about Italy in the event's many cultural exhibits. On hand in 2004 to answer questions about genealogy were members of Pursuing Our Italian Names Together, Chapter 22-Milwaukee, a national association encouraging study of the Italian genealogy. Pictured from left to right are cousins George Koleas (Alioto, Costa), Val Schleicher (Balistreri, San Filippo), and John Balistreri. (Photo by author.)

Having a good conversation between their work at Festa are, from left to right, Joe Collura (a member of the ICC board), Sal Quarino, and Sam Cefalu. Collura's mother Mary Cascio came to Milwaukee when she was 14. His father, Ignatius Collura, was 18 when he came stateside to work as a miner. Both parents were from Sicily. (Photo by author.)

Heading out to work their shift at the bocci courts, John Corbo and his wife Sandra Rende Corbo stopped to discuss their many years of volunteering at Festa. Corbo, the manager of a metal stamping plant, traveled alone to Milwaukee at age 17 from Benevento. When he first arrived in the city, he stayed with his Uncle John Corbo, who had worked at A.O. Smith for 35 years after coming to America in 1922. Sandra, an electrologist, came to the United States in 1973 from her hometown of Cosenza, Calabria. The couple were married in 1976 and have two daughters, Josie, an architect with Crate and Barrel, and Christina, a business administrator with Insty-Prints. (Photo by author.)

# FOR FURTHER READING

Anello, John-David. *Musical Memories, Second Edition*. John-David Anello: Shorewood, WI. 1994.

Armstrong, Alicia, "Little Italy: 'Patient Is Looking Up,'" *The Milwaukee Sentinel*, August, 2, 1978.

Boyd, Thomas, "Milwaukee's Italians Keep Him Busy," *The Milwaukee Journal*, July 25, 1979.

Carini, Mario A. *Milwaukee's Italians: The Early Years*. Italian Community Center of Milwaukee: Milwaukee, WI. 1999.

ed., "Solemn Mass Sunday Will Mark Farewell Spiritual Activity at 'Little Pink Church," *Catholic Herald Citizen*, July 29, 1967.

ed. *The Italian Times*. Italian Community Center, Milwaukee, WI.

Gintoft, Ethel, "Festa Italiana's Religious Rites Trigger Tears, Joy and Memories," *Catholic Herald Citizen*, August 4, 1979.

Gurda, John. *The Making of Milwaukee*. Milwaukee County Historical Society: Milwaukee, WI. 1999.

Janz, Bill, "Needles With Fine Thread of Humor," *The Milwaukee Sentinel*, January 30, 1978.

Joslyn, Jay, "A Sentimental Journey to 'Little Italy,'" *The Milwaukee Sentinel*, July 24, 1979.

Marose, Ron, "Last Days of Pompeii Church Near," *The Milwaukee Sentinel*, July, 1967.

Matichek, Kathleen, "Scattered Italians Cling to Their Roots," *The Milwaukee Journal*, August 26, 1974.

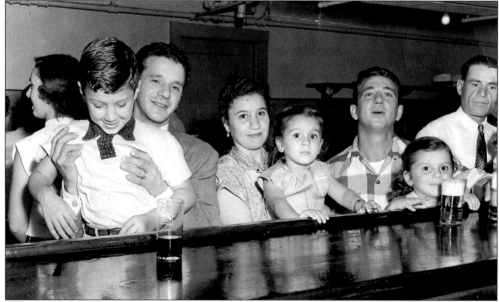

The 1952 wedding of Tom and Jane Balistreri brought out the relatives. Celebrating at the St. Francis Church hall were Fred Vella (who was held by Tony Balestrieri), Rose Vella, Mary Vella, Peter Vella, Nina Vella, and a Mr. Notaro. (Photo courtesy of the Vella family.)